*Creating Textures in*

# COLORED PENCIL

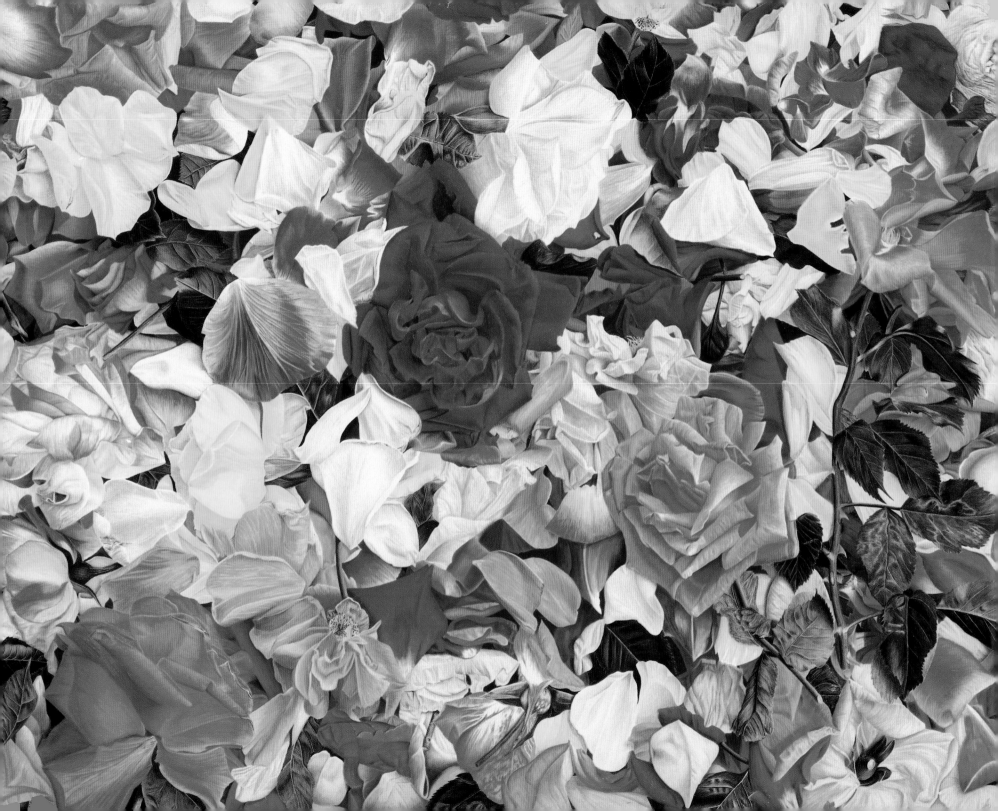

# Creating Textures in
# COLORED PENCIL

## Gary Greene

**NORTH LIGHT BOOKS**
CINCINNATI, OHIO

*Petals, 32" x 40"*

00  99          5  4

**Library of Congress Cataloging-in-Publication Data**
Greene, Gary
      Creating textures in colored pencil / by Gary Greene.
                p.  cm.
      Includes index.
      ISBN 0-89134-653-8 (alk. paper)
      1. Colored pencil drawing—Technique.  2. Texture (Art)
I. Title.
NC892.G74  1996
741.2'4—dc20
                             95-22911
                             CIP

Edited by Pamela Seyring
Designed by Angela Lennert

*Artist's Statement*

Art is, to me, the very essence of life. Because of my main interests in art, namely graph-

ic art, photography and fine art, few moments go by that I'm not thinking art. Once, I was

asked what I was going to do when I retired. I rhetorically responded, "Do you think that

I'm going to sell my cameras someday and never take another photograph or give all my

colored pencils away and never do another piece of art?" Another remark that I frequently

hear (regarding my colored pencil paintings) is, "It must take a lot of patience to do that!"

I enjoy working for hours and hours on my colored pencil paintings!

More significantly, the success of any artist not only depends on his or her talent, but

on the support and understanding of loved ones, who must allow the artist time and space

to create. Thanks, Patti. Thanks, Gregg.

*Gary Greene*

# Table of Contents

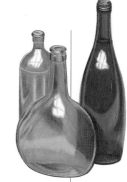

Part Four

# Man- Made Textures

As Founder of the Colored Pencil Society of America (CPSA), it is with great pride and a certain degree of awe that I introduce this book by Gary Greene. It is not only a tribute to the growth and acceptance of the colored pencil medium, but also to the many artists, such as Gary, who are finally receiving the recognition they deserve.

Ten years ago, colored pencil was an obscure medium at best. There were probably three books on the subject and fewer colored pencil workshops or classes. Just as rare was its presence in galleries and museums. Those of us who explored the versatility of colored pencil did so as pioneers through trial and error. We were self-taught out of necessity, often feeling isolated, and sometimes defensive, in our efforts. Fortunately, that picture has changed.

Today, with over 1,300 CPSA members internationally, we celebrate our mutual interest with an annual exhibition and, more importantly, share our discoveries. This book is an example of that spirit. Gary unselfishly imparts his many self-found 'secrets' in creating rich, believable textures made by nature and man.

Regardless of your level of accomplishment with colored pencil, this book will serve as an indispensable handbook. You won't find any pompous art jargon, only easy-to-follow techniques for adding richness and contrast to your colored pencil paintings. Each page is a graphic "show and tell" of information, and like its author, there is nothing pretentious about it. Gary Greene, my friend and colleague, in not only a professional who teaches, he is also an accomplished artist who inspires.

*Vera Curnow*
**Colored Pencil Society of America**

A major premise in the science of Chaos states that a butterfly flapping its wings in Africa can eventually lead to a hurricane in the Caribbean. With this in mind, I look back to a seemingly ordinary day in 1983. While in an art store, I discovered a new book, **The Colored Pencil** by Bet Borgeson. After a cursory thumb through, I decided to buy it, never imagining that twelve years later, I would be writing a book of my own on colored pencil.

With my first attempt at colored pencil, I felt that I was doing something relatively unique. Who ever heard of a colored pencil painting? As a matter of fact, I didn't even consider calling my colored pencil art a 'painting,' but as I began to understand the medium, referring to my art as a "painting" became more apropos than a "drawing."

The more I painted, the more my confidence with colored pencil grew, so I began to exhibit my work. I was amused at the response. People were (and still are) absolutely amazed that the art was done with colored pencils.

In 1990, I realized a another major milestone in my 'affair' with the colored pencil:

I responded to a letter to the editor in **The Artist's Magazine,** from Vera Curnow, a woman in Michigan wondering if anyone was interested in organizing a society for colored pencil artists. Not being a joiner, of course I was interested! It was then that the Colored Pencil Society of America (CPSA) was founded by Ms. Curnow. Five years later, the CPSA enjoys a rapidly expanding international membership of 1,300 colored pencil artists. Through my association with the CPSA, I was able to have my work published in major art books and magazines, began to teach workshops in colored pencil, and was finally given the opportunity write this book and share my passion for this medium with a large audience of artists.

For those of you who are new to colored pencil, this book will introduce you to a medium that offers versatility, control, simplicity, depth and discovery. Colored pencil gives the artist an opportunity to be truly creative, because it is not (to my knowledge) formally taught at any college or art school, enabling you to do whatever you want—no rules, no "do's," no "don'ts," no limits. As more gifted colored

pencil artists emerge, the medium gains more acceptance, by galleries, publishers, and buyers.

If you have already tried colored pencil and would like to take it to the next level, this book will enable you to explore aspects of colored pencil that you may not have been aware of: the importance of reference material, as well as the use of solvents, water soluble pencils and various techniques.

Regardless of your expertise, the purpose of this book is to get your 'creative juices' flowing, by painting interesting, realistic textures with colored pencil, then applying what you glean to develop unique colored pencil paintings. Who knows, as you thumb through this book at your local art store, where it will lead you?

*Gary Greene*
*Woodinville, Washington*
*April 1995*

# Materials and Tools

∞

The most commonly asked questions from newcomers to colored pencil art are, "What kind of colored pencil should I use? What's the best brand?" The answers to these questions, together with information about paper surfaces, erasers, sharpeners, solvents, brushes, and everything else you'll need to get started, are explained in this section. Although you may be familiar with many of the materials and tools described, you may not be aware of their application for creating colored pencil paintings.

*'50 Buick, 24" x 32"*

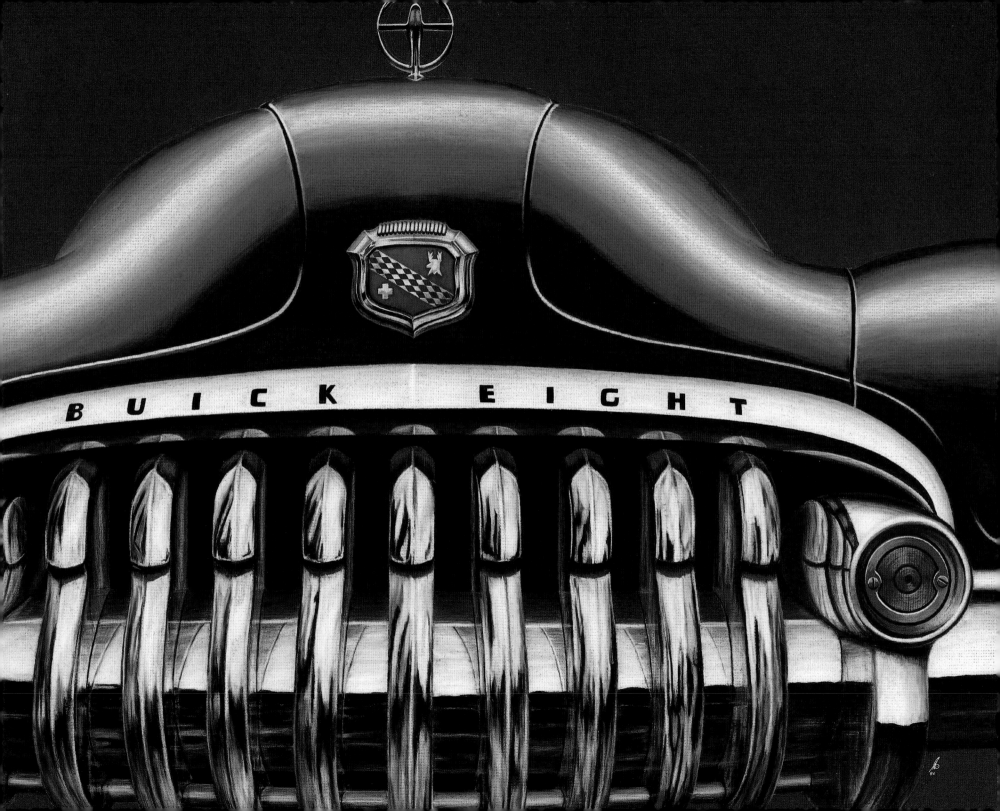

# Colored Pencils

There are many things to consider when selecting the "right" colored pencil for your painting. Factors include the overall quality of the pencil, whether it will do the job it's intended for, range of colors, and availability.

Colored pencils can be divided into three basic types: wax-based, oil-based and water-soluble. Each has their own special characteristics and applications.

## Wax-Based Pencils

Wax-based pencils are identified by the wax binder that holds their pigment together. Their thick, soft leads have a "buttery" feel when applied to the paper, making them suited for most techniques. Wax-based colored pencils are the most commonly used, probably because they are the most widely available. Although wax-based pencils are not water soluble, effects similar to those done with water-soluble colored pencils can be created using various solvents such as turpentine, rubber cement thinner or colorless marker. Popular wax-based colored pencil brands are Berol Prismacolor, Design Spectracolor, and Derwent Artists Series pencils.

Prismacolor pencils offer three types of gray: Cool Grey, Warm Grey and French Grey, with value gradations of 10%, 20%, 30%, 50%, 70% and 90% for each, making them extremely useful.

Other wax-based colored pencils include hard lead and colored pencil sticks. Berol Verithin pencils have thin, hard leads good for detail work, layout outlining, and cleaning up ragged edges left by softer, thick-lead pencils.

Berol Prismacolor Art Stix are rectangular, resembling pastels, but they are made of the same material as Prismacolor pencils. Their size and shape make Art Stix a good choice for covering large areas and laying broad strokes. They are available in colors compatible with selected Prismacolor pencil colors.

## Oil-Based Colored Pencils

These are newcomers to the scene. Similar to wax-based pencils, they differ in two respects: the pigment is bound together with an oil medium, eliminating wax bloom (see page 28), and they are softer than wax pencils.

The primary oil-based colored pencil brands are Lyra Rembrandt Polycolor and Caran D'Ache Pablo Colors. Both are superb in quality and can be combined with wax-based pencils. They may also be thinned with solvents like their waxy counterparts.

## Water-Soluble Pencils

Water-soluble pencils have a different "feel" than wax- and oil-based pencils. Not as soft and "buttery" when applied dry, they are gaining considerable popularity for their unlimited versatility.

Quality brands of water-soluble pencils include Derwent Watercolour Pencils, Caran D'ache Supracolor II, Lyra Rembrandt Aquarelle and Design Watercolor pencils. They are available in colors matching their wax- or oil-based counterparts.

# Colored Pencil Comparisons

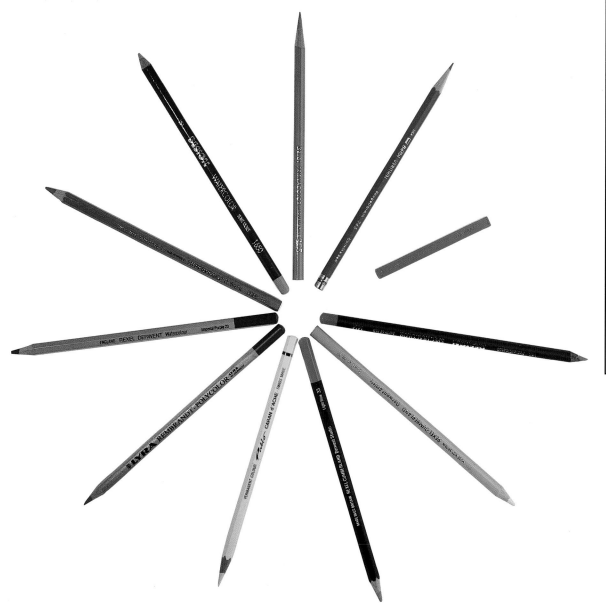

| Pencil Type | Brand | Color Range |
| --- | --- | --- |
| Soft Wax | Berol Prismacolor | 120 |
| Hard Wax | Winsor & Newton Derwent Artists' | 72 |
| Soft Wax | Faber Castell Design Spectracolor | 96 |
| Soft Wax | Derwent Studio | 72 |
| Hard Wax | Berol Verithin | 36 |
| Wax Stick | Berol Prismacolor Art Stix | 48 |
| Oil-Based | Caran D'Ache Pablo | 120 |
| Oil-Based | Lyra Rembrandt Polycolor | 72 |
| Water Soluble | Caran D'Ache Supracolor II | 120 |
| Water Soluble | Winsor & Newton Derwent Watercolour | 72 |
| Water Soluble | Lyra Rembrandt Aquarelle | 72 |
| Water Soluble | Design Watercolor | 48 |

# Erasers

Colored pencil artists are universally concerned with the application of their medium, but there is another factor to consider—taking it off. The most familiar method for removing colored pencil is the eraser. But there are so many kinds of erasers. Which ones work best and for what purposes? Are there other ways to remove colored pencil?

The photographs illustrate applications of the more common erasers and "lifting" materials used with colored pencil work. As you can see from the swatches, these tools can also be used to blend and smooth pigment for interesting effects. To some colored pencil artists, the eraser is as essential to their technique as the pencil.

All erasers were tested on two different surfaces. The swatches shown here on top were done on a 4-ply, medium-textured Crescent museum board. The bottom ones were applied to a very smooth (no grain) Strathmore bristol board. The three samples on each surface show how the eraser performed on (a) smeared colors, (b) lightly applied colors, and (c) heavily applied colors.

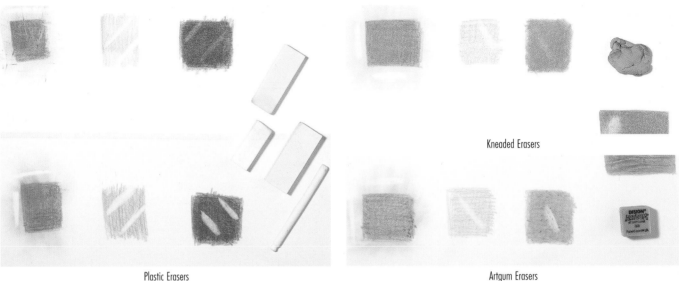

Kneaded Erasers

Plastic Erasers

Artgum Erasers

## Plastic Erasers

Plastic erasers come in many shapes, sizes and densities, from hard to extra soft. They are useful for removing smeared pigment and smudged borders. They also work well on drafting film. Extra-soft plastic erasers won't damage the surface of lightweight papers. Plastic erasers are more effective in removing lightly applied colors than in heavy applications. The erasures are more dramatic on a smooth surface than on a surface with a tooth.

## Kneaded Erasers

These are indispensable for colored pencil artists, because they can be stretched and shaped to work in small areas. By pressing down and pulling up, you can "lift" pigment from the surface. Kneaded erasers should be tested first because they can damage some delicate papers. They are less effective on smooth surfaces than those with a tooth.

## Artgum Erasers

Artgum erasers work well on a toothy surface for removing smudges and lightly applied color. They do remove some heavily applied color and work fairly well on smooth paper, but all in all, are not as effective as the plastic erasers. Block artgum erasers are "crumbly"; you'll need a brush to remove the residue.

# Erasers

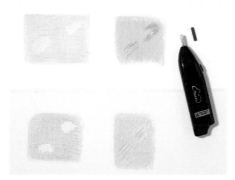

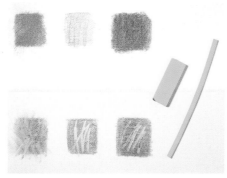

## Electric/Battery Operated Erasers

These can be used for quick removal of color. A variety of eraser strips are made to fit them. They are available in both plug-in (AC) and battery-operated (DC) types. If care is not taken, particularly in the choice of eraser strips, paper surfaces can be quickly distressed, ruining your painting. Interesting effects can be achieved by experimenting with these erasers. Keep a brush handy to remove crumbs.

## Imbibed Erasers

These come in blocks or strips for use in electric erasers. Imbibed erasers are very effective in lifting heavily applied colored pencil layers without damaging delicate paper surfaces.

## Frisket Film and Paper

Another method for removing or "lifting" colored pencil is frisket films and papers. These are reusable, low-tack, clear or matte masking films with a peel-off paper backing. Their applications are boundless. To lift color, cut the film into any shape you want, burnish it onto the paper and peel it back. New color can then be applied into the lifted area for interesting color mixes. With frisket film, mistakes can be corrected, highlight areas created, or dark lightened. Test a sample on the paper you use, to make sure it won't alter the surface. Frisket paper can also be used for masking, especially larger areas.

## Removable Tape

This is a low-tack tape, available in 1/2", 3/4" and 1" widths and can be used like frisket film. It is also an excellent, inexpensive way to mask small areas.

# Surfaces

Choice of surface depends on your desired effect. Colored pencil can be applied to just about anything. Sory Marocchi exhibited a piece rendered on the front of a T-shirt in the Colored Pencil Society of America's 1993 International Exhibit. Another artist, Maggie Toole, works with overlapping circles on fine hardwood.

## Texture

Papers can be described by their texture, or tooth. The more tooth, the rougher the surface. For example, if a cross section of rough watercolor paper were magnified, it would be apparent that it consists of "hills" and "valleys" whose height determine the paper's roughness. Smooth surfaces include scratchboard (cardboard coated with a clay finish) and drafting film. In addition, many artists prepare their surfaces with gesso, a white primer that can be textured or sanded smooth.

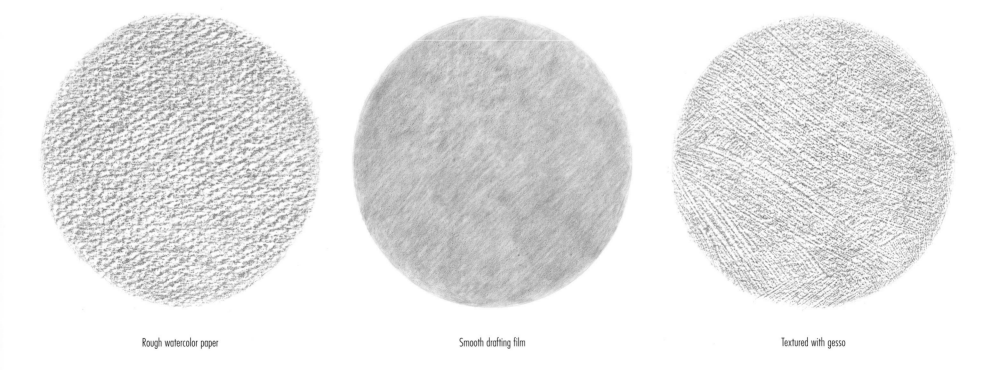

Rough watercolor paper                          Smooth drafting film                          Textured with gesso

# Surfaces

## Surface Color

Because colored pencil is a translucent medium that allows some light to pass through it, the underlying surface usually shows through the layers on top. Thus, a white surface is perfect for depicting the purity and vibrancy of color. Colored stock may be used for different effects.

## Longevity

Rag (cotton fiber) content and pH (acid/alkaline balance) are the two major factors that determine a paper's longevity. One hundred percent acid-free paper has a relatively neutral pH, which is desirable because it resists yellowing and deterioration over an extended period of time.

## Strength

Paper should be able to withstand many heavy applications of pencil, erasure and solvent or water.

## Recommendations

Strathmore 4-ply museum board is 100 percent acid free, with a medium tooth perfect for both heavy burnishing and traditional layering. It withstands repeated erasure, as well as applications of solvent and water, without surface damage or buckling. It's available in white, black, gray and beige in 32" x 40" sheets. Two-ply bristol vellum board, medium tooth, is also good for general artwork.

Experiment with different paper textures and colors to find one that best suits the effects you want.

Colored paper

Medium bristol vellum board

# Solvents

Wax- and oil-based colored pencils can be worked similarly to water soluble pencils by using solvents such as turpentine, rubber cement thinner and colorless blenders. Instead of repeatedly layering and burnishing to cover the paper surface, applying solvent to a moderately layered area of colored pencil can save a considerable amount of time. This technique works particularly well in areas of solid color.

### Odorless Turpentine

When applied with a brush or cotton swab, this solvent, sometimes called Turpenoid, will produce an effect similar to watercolor or water soluble pencil washes. Turpenoid dries more quickly than water, which results in a more even application of color. Use adequate ventilation.

### Rubber Cement Thinner

This works like turpentine on wax- and oil-based pencil, with one major difference: it dries much more quickly, producing more of an opaque wash. Rubber cement thinner and odorless turpebtine have toxic ingredients that are not only harmful to inhale but can cause problems through skin contact. Follow the warning labels on the container. When using them, pour a small amount into a glass container with a narrow mouth and a secure cap. Loosen the cap and, without removing the cap completely, dip the brush or swab in the solvent. Immediately replace the cap to minimalize escaping vapors.

### Colorless Blenders

These produce interesting strokes. Wipe applicator thoroughly after each color, because residue can contaminate the next color. Colorless markers also have highly toxic contents with a nauseating odor.

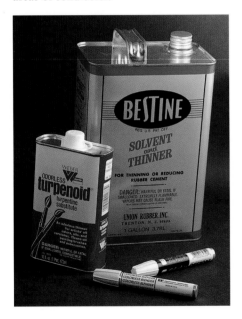

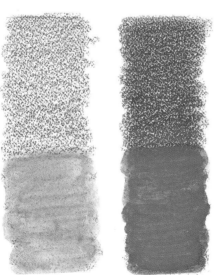 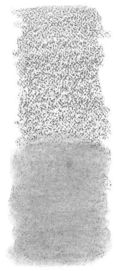 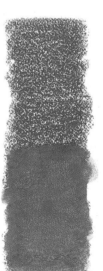 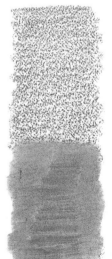 

Odorless turpentine                    Rubber cement thinner                    Colorless blender

# Other Tools and Materials

### Pencil Sharpeners

There are three basic types of pencil sharpeners: manual, electric and battery operated. Manual sharpeners are available in two types: small hand held models and desk, or "office," types that have a crank and a container for shavings. Both have a longer life span than electric or battery operated styles, are less costly, but require more time to sharpen, and may cause injury to the hand or wrist if used repeatedly. The primary advantage of electric pencil sharpeners over manual models is their ability to put a very sharp point on a pencil in a manner of seconds without requiring potentially injurious, repetitive hand movement. Battery operated sharpeners offer all the advantages of corded models, plus portability. Constructed of lightweight plastics, battery operated sharpeners, like corded models, are really intended for graphite pencils and do not hold up particularly well to waxy (or oily) colored pencil binders, which have a tendency to clog the sharpening mechanism and burn out their small motor. The choice the artist makes can be as subjective as his or her own personality.

### Pencil Extenders

A pencil can be sharpened to a length limited by the depth of the pencil sharpener. Pencil extenders attach to the pencil, so it can be held comfortably when sharpened to a stub.

### Graphite Pencils

These are used when laying out your art. Care should be taken to use medium-soft leads—B, 2B or 3B, for example—because harder leads can impress a permanent line that will be particularly apparent when light layering techniques are used.

### Brushes

Brushes are used to create washes with water-soluble or wax/oil-based pencils. The textures described in this book that utilize washes or underpainting involve small areas of coverage, so watercolor brushes ranging in size from no. 2 through no. 6 will suffice in most cases.

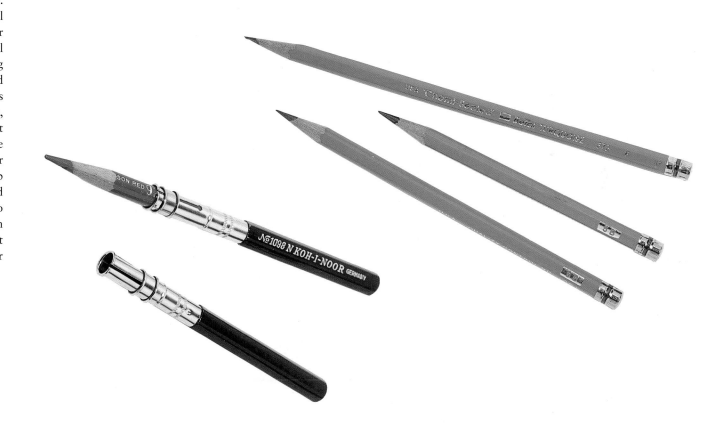

# Other Tools and Materials

### Cotton Swabs

These are indispensable as applicators when using solvents. It's strongly advised that you use swabs with long, wooden applicators—available at hospital supply stores—because there is less likelihood that the solvent can "creep up" the applicator and get on your fingers. Use cotton balls for larger areas. For very large areas, use a soft cloth. Rubber gloves are recommended when using cotton balls or cloth applicators with solvents.

### Hair Dryer

A hair dryer should be used to dry water-soluble pencil washes (NOT solvents!) to minimize warping, or to prevent the paper surface from lifting when using some boards.

### Desk Brush

A desk brush helps to keep the art you're working on free of colored pencil debris. If debris is not removed, it can lodge in the paper's "valleys," causing smearing and/or impure color. This type of error may be difficult to remove, and could ruin your painting. A desk brush or a large, soft paintbrush will minimize problems with debris.

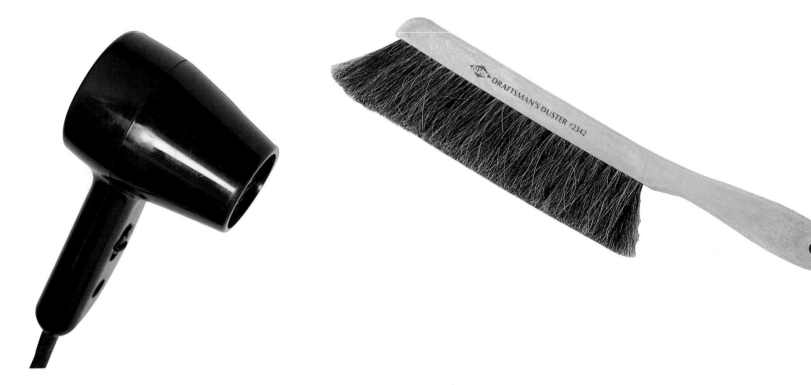

# Other Tools and Materials

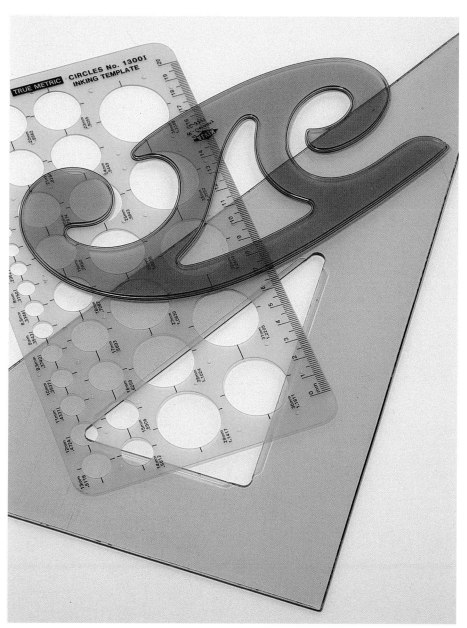

### Templates

These are particularly useful when creating realistic, man-made subjects, laying out a painting, or cleaning up ragged edges. They come in many forms: straightedges, circle/ellipse guides, French curves and ship curves (rulers that can be bent into various curves as an aid in scribing lines).

### Erasing Shields

Erasing shields are thin, metal templates with a series of slots that allow you to erase small, tight areas with an electric eraser.

The shield is positioned on the art so only the area to be erased is exposed in the desired slot, allowing selective erasing. Erasing shields are inexpensive and can be purchased at any art supply store.

### Sandpaper

A medium grade sandpaper is useful for flattening pencil points or sharpening electric eraser strips so they can be used to erase tight areas.

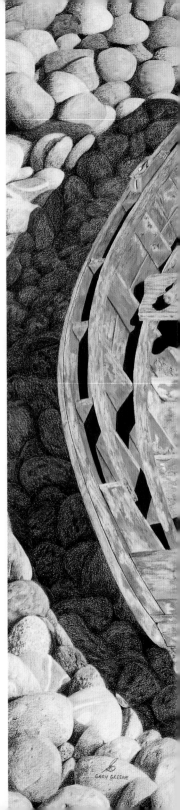

*Part Two*

# The Basics

∞

Textures are only one part, an integral part, of a painting. Therefore, before we study individual textures, the preparation of a colored pencil painting should be studied. This includes selecting a subject, preparing a layout, and choosing a technique best suited for your painting.    ∞    Colored pencils have unique properties. They are neither opaque like pastels, nor transparent like watercolors. They are *translucent,* that is, somewhere in between.    ∞    The translucent properties of colored pencil permit strokes to be layered on top of one another, from dark to light. When applied in this manner, the darker colors will show through the lighter ones. The lighter colors will have enough opacity to partially cover and take on hues of the underlying, darker colors. Most textures in this book are created using this basic approach.

*A Couple on the Rocks,* 25¼" x 37"

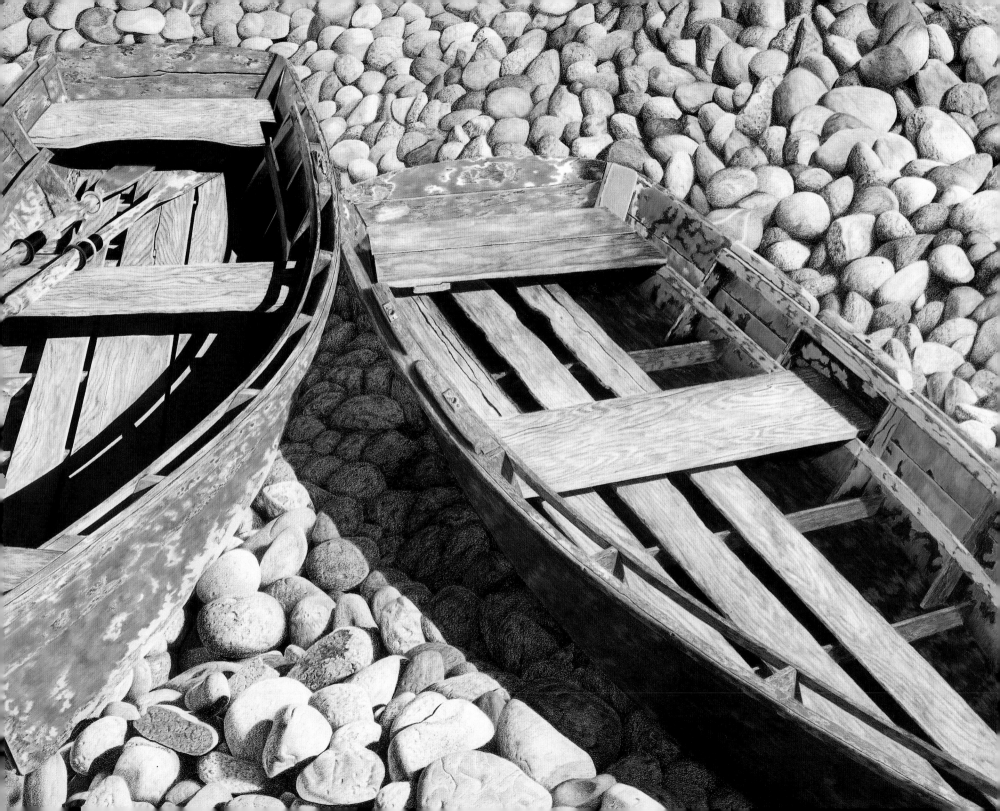

# Selecting a Subject

The first consideration in selecting a subject for a colored pencil painting, or *any* artistic endeavor, is that the subject pleases the artist, that it's something he or she is interested in, is fascinated by, or has intimate knowledge about. Regardless if the objective is to paint for fun or to be a professional artist and sell your work, avoid advice to paint what ever is "in" at the time. As a matter of fact, don't accept any unsolicited advice as to *what* to paint. This should always be the artist's decision.

Strive to set your art apart if you want to exhibit or sell it. Aside from being well executed and composed, your art must stand out. To achieve this, either choose unusual subjects or present ordinary subjects in an extraordinary way. Because of limited appeal, unusual subjects may be more difficult to sell, but a common subject with universal appeal, if presented in a remarkable way, will stand a far greater chance of being exhibited, sold, or winning an award. Try to paint subjects with interesting or intense colors and from an unusual perspective.

## Use Original Sources
When choosing a subject, artists should be aware that if they want to display their art anywhere outside their own living room, it should be *original,* that is, not *copied* from any source, such as photos or art from magazines, books, etc. If you must use copyrighted material for reference (*anything* printed is copyrighted, unless otherwise specified), either get permission to copy it or change it enough so it isn't the same work. Aside from ethical considerations, art that is plagiarized can be removed from an exhibition with forfeiture of awards, and legal action can be taken against the artist.

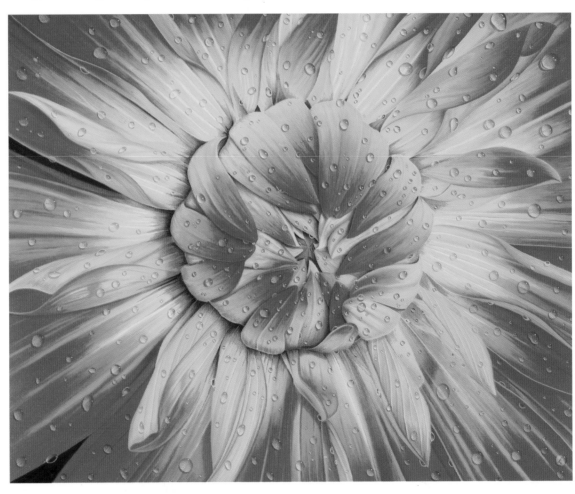

Florals are frequently chosen as art subjects, but no matter how well rendered, flowers are often overdone. *Flower Power* (32" x 40") presents a frame-filling, close-up view of a dahlia that *commands* you to look at it, making it an obvious example of an ordinary subject presented in an extraordinary way.

*Hulls,* 25½" x 38"

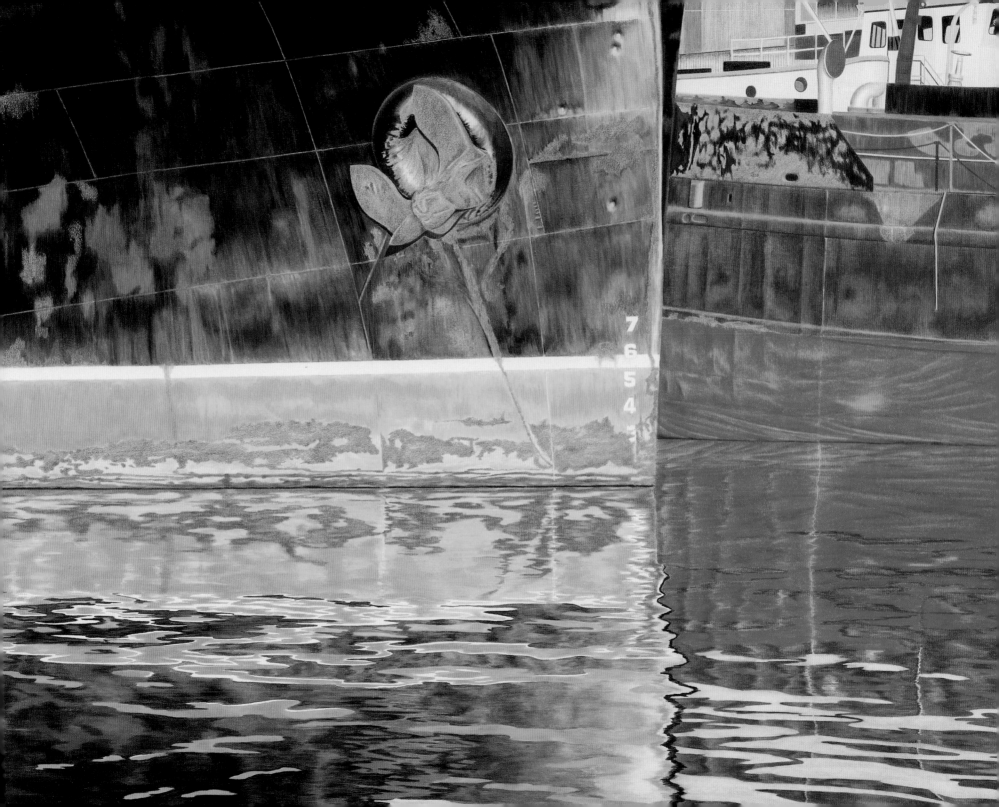

# Reference Art

In order to portray textures with colored pencil, it's essential to have good reference art. Subjects should be closely studied and understood, because colored pencil paintings require considerably more time to complete. It's important that the subject you're painting doesn't change over a period of time—even the slightest change in lighting or position may greatly affect the subject. The solution to these considerations is photography.

Slides of subjects photographed by the artist are suggested for use as reference in colored pencil paintings, because slides offer the best way to observe and understand textures. It is possible to work from a single image, or a main photo plus several similar photos of the same subject taken from different angles, or a combination of different images. For example, here kites were used from one photo and clouds from another.

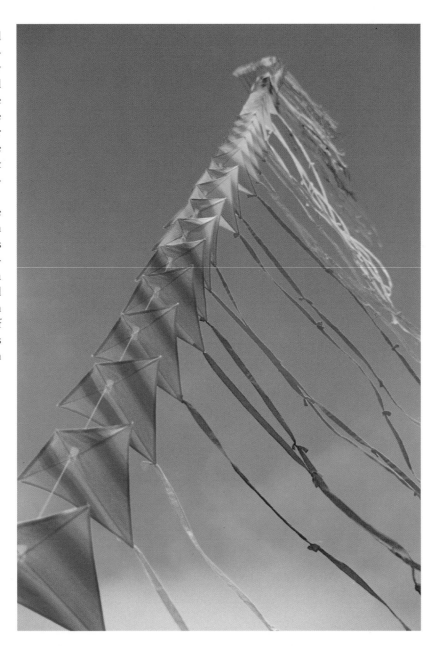

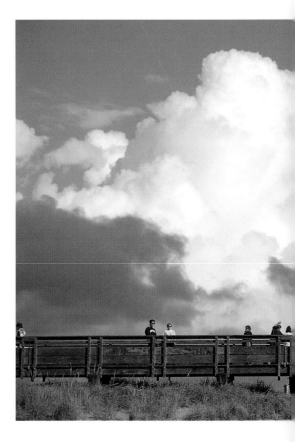

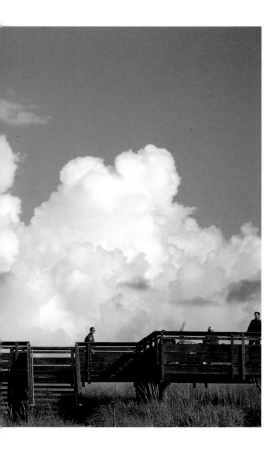

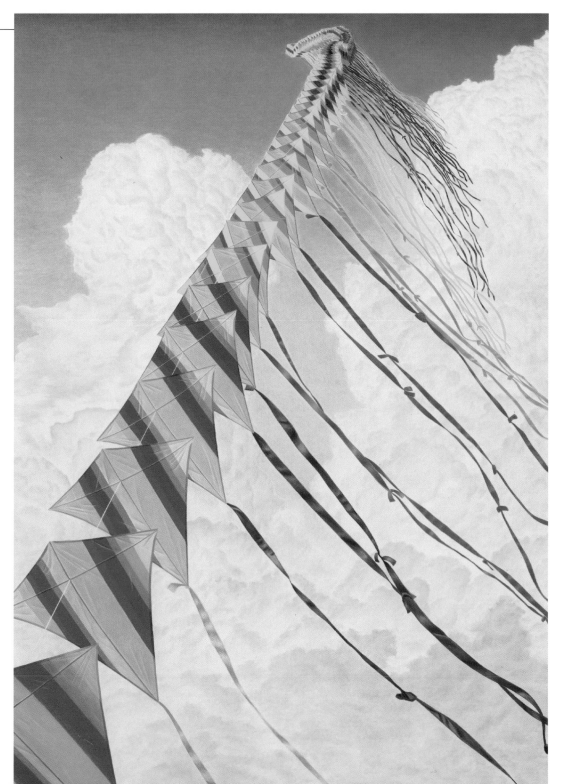

*Kites*, 35" x 25"

# Deciding on Colors

Determining what colors will be needed before starting a painting is particularly important, because unlike liquid media, colored pencils are not mixed on a separate palette and then applied to the painting. They're mixed directly on the painting as it's completed, resulting in a greater chance of inaccurate colors. In addition, some "final" colors may be very complex, consisting of many layers of different "straight" colors. Finally, by determining what colors to use in advance, you can estimate how many and what colors to buy, reducing trips to the art store and saving money by allowing you to order pencils from mail-order houses.

Buy a *complete* set of each brand you've chosen, using the information in section one. Use the set for color reference *only*. Next, determine the color palette needed to complete each piece. This is done by experimenting with different combinations of pencils, as shown here. Estimate how many pencils of each color you'll need, then buy pencils individually. This is called buying open stock. Be sure that the colored pencils you chose are readily available in *open stock,* or you may end up being frustrated looking all over town or waiting for a mail-order house to deliver the colored pencils you used up to complete your piece.

# Deciding on Colors

C olor combinations were determined by experimenting with different combinations of colored pencils.

Beige
Tuscan Red
Warm Grey 70%

Apple Green
Chartreuse

Warm Grey 70%
Apple Green
Limepeel

Limepeel
Apple Green

Apple Green
Yellow Bice

Warm Grey 20%
Yellow Orange

Tuscan Red
Indigo Blue

Canary Yellow

White Paper

Canary Yellow

Sunburst Yellow
Canary Yellow

Vermillion
Orange

Scarlet Red
Vermillion

Scarlet Lake
Scarlet Red

Crimson Red
Scarlet Lake
White

Crimson Red
Scarlet Lake

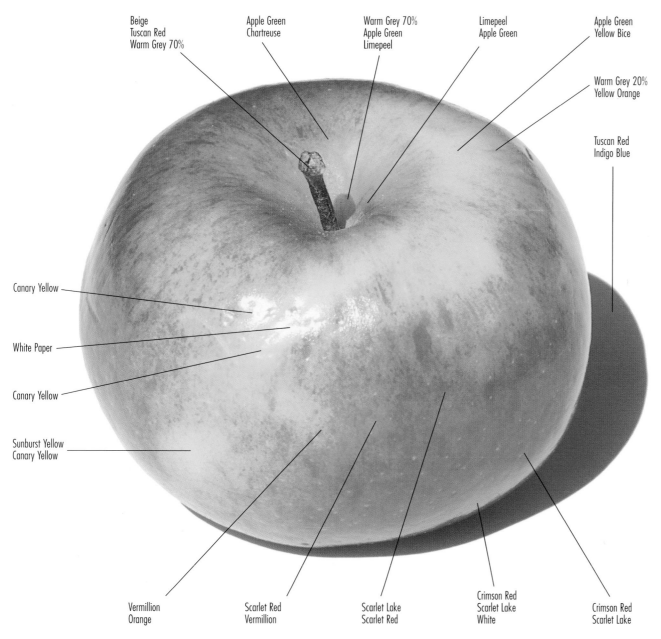

# Master List of Colors

## Berol Prismacolor

| | | | | | | | |
|---|---|---|---|---|---|---|---|
| 901 | Indigo Blue | 924 | Crimson Red | 947 | Dark Umber | 1012 | Jasmine |
| 903 | True Blue | 926 | Carmine Red | 948 | Sepia | 1013 | Deco Peach |
| 906 | Copenhagen Blue | 927 | Light Peach | 989 | Chartreuse | 1014 | Deco Pink |
| 907 | Peacock Green | 928 | Blush Pink | 991 | Light Yellow Green | 1015 | Deco Blue |
| 908 | Dark Green | 929 | Pink | 992 | Light Aqua | 1016 | Deco Aqua |
| 909 | Grass Green | 930 | Magenta | 993 | Hot Pink | 1018 | Pink Rose |
| 910 | True Green | 931 | Dark Purple | 994 | Process Red | 1019 | Rosy Beige |
| 911 | Olive Green | 932 | Violet | 995 | Mulberry | 1020 | Celadon Green |
| 912 | Apple Green | 933 | Violet Blue | 996 | Black Grape | 1021 | Jade Green |
| 913 | Green Bice | 934 | Lavender | 1002 | Yellowed Orange | 1022 | Mediterranean Blue |
| 914 | Cream | 937 | Tuscan Red | 1003 | Spanish Orange | 1023 | Cloud Blue |
| 916 | Canary Yellow | 939 | Peach | 1004 | Yellow Chartreuse | 1024 | Blue Slate |
| 917 | Sunburst Yellow | 941 | Light Umber | 1005 | Limepeel | 1025 | Periwinkle |
| 918 | Orange | 942 | Yellow Ochre | 1006 | Parrot Green | 1026 | Greyed Lavender |
| 921 | Pale Vermillon | 943 | Burnt Ochre | 1008 | Parma Violet | 1031 | Henna |
| 922 | Poppy Red | 944 | Terra Cotta | 1009 | Dahlia Purple | 1032 | Pumpkin Orange |
| 923 | Scarlet Lake | 945 | Sienna Brown | 1010 | Deco Orange | 1033 | Mineral Orange |
| | | 946 | Dark Brown | 1011 | Deco Yellow | 1034 | Goldenrod |

# Master List of Colors

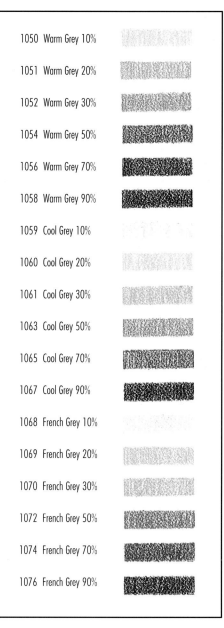

| | |
|---|---|
| 1050 | Warm Grey 10% |
| 1051 | Warm Grey 20% |
| 1052 | Warm Grey 30% |
| 1054 | Warm Grey 50% |
| 1056 | Warm Grey 70% |
| 1058 | Warm Grey 90% |
| 1059 | Cool Grey 10% |
| 1060 | Cool Grey 20% |
| 1061 | Cool Grey 30% |
| 1063 | Cool Grey 50% |
| 1065 | Cool Grey 70% |
| 1067 | Cool Grey 90% |
| 1068 | French Grey 10% |
| 1069 | French Grey 20% |
| 1070 | French Grey 30% |
| 1072 | French Grey 50% |
| 1074 | French Grey 70% |
| 1076 | French Grey 90% |

## Berol Verithin

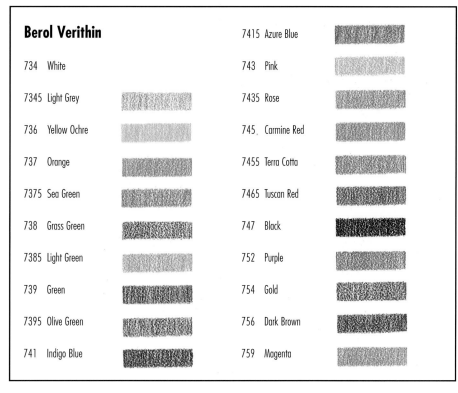

| | | | | | |
|---|---|---|---|---|---|
| 734 | White | | 7415 | Azure Blue | |
| 7345 | Light Grey | | 743 | Pink | |
| 736 | Yellow Ochre | | 7435 | Rose | |
| 737 | Orange | | 745 | Carmine Red | |
| 7375 | Sea Green | | 7455 | Terra Cotta | |
| 738 | Grass Green | | 7465 | Tuscan Red | |
| 7385 | Light Green | | 747 | Black | |
| 739 | Green | | 752 | Purple | |
| 7395 | Olive Green | | 754 | Gold | |
| 741 | Indigo Blue | | 756 | Dark Brown | |
| | | | 759 | Magenta | |

## Design Spectracolor Pencils

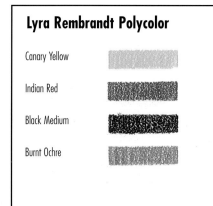

| | |
|---|---|
| 1410 | Real Green |
| 1423 | Canary Yellow |
| 1426 | Crimson Lake |
| 1432 | Slate Gray |
| 1437 | Sand |

## Lyra Rembrandt Polycolor

| |
|---|
| Canary Yellow |
| Indian Red |
| Black Medium |
| Burnt Ochre |

## Derwent Watercolour Pencils

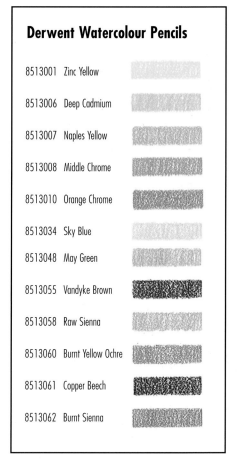

| | |
|---|---|
| 8513001 | Zinc Yellow |
| 8513006 | Deep Cadmium |
| 8513007 | Naples Yellow |
| 8513008 | Middle Chrome |
| 8513010 | Orange Chrome |
| 8513034 | Sky Blue |
| 8513048 | May Green |
| 8513055 | Vandyke Brown |
| 8513058 | Raw Sienna |
| 8513060 | Burnt Yellow Ochre |
| 8513061 | Copper Beech |
| 8513062 | Burnt Sienna |

## Design Watercolor

| | |
|---|---|
| 1611 | Lemon Yellow |
| 1623 | Canary Yellow |

# Layout

There are three basic ways to lay out a painting: draw the subject; trace the subject and transfer it to the painting; or project the subject onto the painting via a slide or opaque projector.

## Keep It Light

Whichever method is used to lay out a painting, it should be done with a medium-soft graphite pencil such as a 2B or B using *very little pressure*. If too much pressure or a hard pencil is used, lines could be impressed on the paper surface, making them difficult to cover when burnishing or impossible to cover when layering. If a graphite pencil that's softer than a 2B is used, it may be difficult to remove the graphite, especially when using a "toothy" paper.

## Make Adjustments

After the initial layout is completed, make adjustments with the graphite pencil. Tools such as straightedges, circle guides, ellipse guides, French curves and ship curves may also be used, if desired, to true up outlines of man-made objects.

## Remove Graphite Lines

Colored pencil is a translucent medium, which allows darker colors to show through layers of lighter color. With this in mind, it's necessary that all graphite be removed before painting begins, otherwise the graphite lines will show through even heavily burnished areas and ruin your painting. To solve this, draw colored lines *next to* (not on top of) the graphite lines, using a hard-lead pencil such as a *Verithin*. Then erase the graphite with a kneaded eraser. The colored pencil lines will remain (they may need to be touched up) even if erased. When doing this second outline, use colors that correspond to the area to be painted. The outlines will disappear when the area is completed. Again, be careful not to press too hard, especially when using *Verithin* pencils, to avoid unwanted impressed lines.

---

### Graphite for First Stage

Colored pencil should not be used instead of graphite in the first stages of laying out a painting because the first lines laid down may require repeated erasure, and because colored pencil lines can never be fully erased without injuring the paper surface.

---

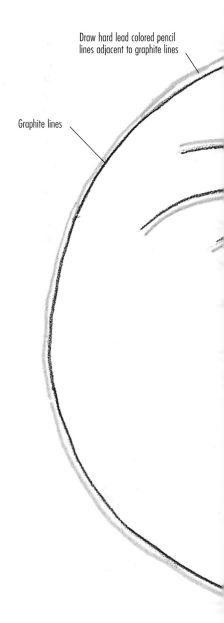

Draw hard lead colored pencil lines adjacent to graphite lines

Graphite lines

*Creating Textures in Colored Pencil*

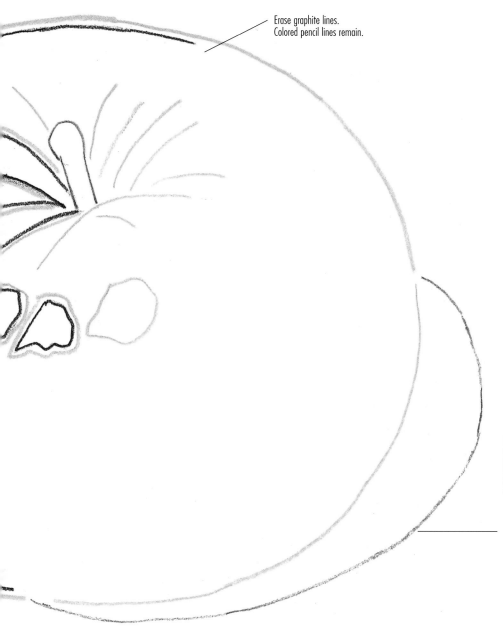

Erase graphite lines.
Colored pencil lines remain.

Grey colored pencil lines

# Techniques

The following pages will show you the three basic techniques, used individually and in combination, that form the basis for the majority of the textures explored in this book. These three techniques are *layering*, *burnishing* and *underpainting*. Note that different techniques can produce the same degree of realism.

## General Guidelines For Creating Textures

- Study the subject—in order to paint textures, you must see and understand the subtleties of the subject.
- Erase graphite layout lines before applying colored pencil.
- Work one area/object at a time, rather than the entire painting.
- Start with the lightest areas first.
- Follow the contours of the object.
- A sharp pencil will produce more intense color in a smaller area.
- A flat pencil will cover more area, with less color intensity.
- For "light" erasing, use a kneaded eraser.
- For "heavy" erasing, use an imbibed eraser, with an electric eraser.
- Keep the art free from pencil "crumbs" with a desk brush. If they become lodged in the paper surface, press the effected area with a kneaded eraser until the "crumbs" are lifted.
- Use a piece of tracing paper under your hand to prevent smudging.
- Leave white paper free of colored pencil for highlights.
- Clean up ragged edges with a hard colored pencil.

# Layering

Layering is a common technique used with colored pencils. Using light pressure and small, circular strokes, colors are layered on top of each other, forming complex hues, values and gradations, starting with the darkest colors first. When layering, the appearance, texture and mood of a painting can be manipulated by using surfaces of varying tooth and/or color, because the paper plays a major role in the technique, as it shows through the layers of pigment.

**1** *Apple Body*—As shown on the previous page, after drawing the apple with B or 2B graphite, redraw it with Verithin hard-lead pencils, adjacent to the graphite. Outline contours and the color-free highlight area with yellow, and the stem with Tuscan Red.

**2** The stem's shadow should be outlined with Apple Green, and the shadow's outer edge with Light Grey.

Following the apple's contours, use small, light, circular strokes of Sunburst Yellow on top of Warm Grey 20% to create a narrow band of darker value near the apple's upper left edge. Gradually fade out Sunburst Yellow toward the center and edge of the apple, leaving the apple's extreme edge free of color.

Starting with the area of the stem's shadow, lightly layer Limepeel and Apple Green on top of Warm Grey 70%. Apply a small amount of Limepeel in the area near the stem, then Apple Green over

the Limepeel, working outward in all directions. Layer over stem shadow, being careful not to blur its edges with excessive pencil pressure. Lighten strokes as green disappears and graduates into surrounding areas. Starting approximately halfway into the Apple Green, layer Chartreuse on top and lighten it as it's worked toward the apple's upper right.

Continue graduating yellow portions of the apple, overlapping them with Yellow Chartreuse (primarily adjacent to Apple Green area), Canary Yellow and Sunburst Yellow. Leave the areas to be the deepest red free of yellow.

**3** Continuing to follow the apple's contours, and still using small, light, circular strokes, evenly apply Crimson Red to the darkest red areas. Lighten strokes into lighter red areas, then layer, in sequence, Scarlet Lake, Poppy Red, Pale Vermilion, and Orange. Graduate each until the yellow areas are reached, then blend with Sunburst Yellow layered over Orange.

To achieve the splotchy effect of apple skin, apply heavier strokes with a well sharpened point, using colors one hue darker than the surrounding area.

**4** Repeat this process until apple, except stem and shadow, is covered with pigment. Be sure to leave the highlight and a thin crescent of white on the right side of the apple free of color.

*Stem*—Apply Light Peach using medium pressure, then layer Tuscan Red and accents of Warm Grey 70% on top.

*Shadow*—Evenly layer with Indigo Blue and Tuscan Red, lightly at first. The final layer should be Tuscan Red to indicate the apple's reflection on the shadow. Clean up ragged edges with hard-lead colored pencils.

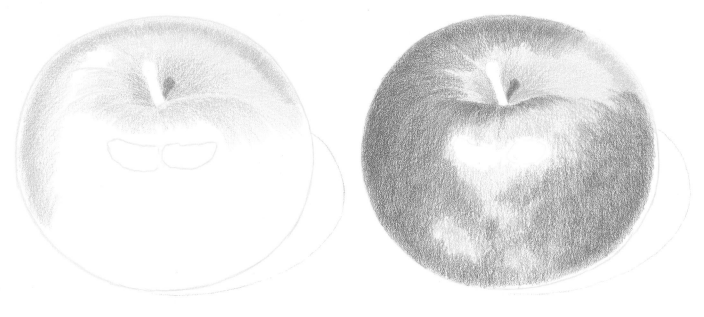

# Layering

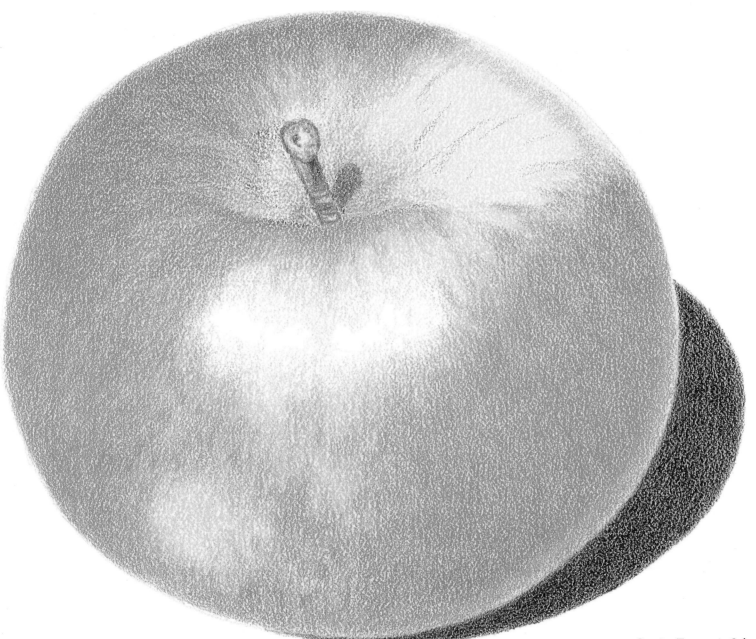

---

**Color Palette**

**APPLE (BODY)**
Apple Green
Limepeel
Chartreuse
Yellow Chartreuse
Canary Yellow
Sunburst Yellow
Warm Grey 20%
Warm Grey 70%
Crimson Red
Scarlet Lake
Poppy Red
Pale Vermilion
Orange
White

**STEM**
Beige
Tuscan Red
Warm Grey 70%

**SHADOW**
Tuscan Red
Indigo Blue

---

# Burnishing

Burnishing involves layering and blending wax- or oil-based colored pencils on top of each other until the *entire* paper surface is covered. The lighter *areas* of color are completed first to prevent darker colors from adjacent areas from being "dragged" into lighter areas. Colors are applied lightly at first by layering lighter colors on top of darker colors. This process is repeated until the paper surface is approximately two-thirds covered with pigment, still allowing the paper surface to show through.

Next, a white or very light colored pencil is used with heavy pressure to blend or *burnish* the layered colors together. The same colors are then re-layered over the white burnished layer of color. The process of layering and burnishing is repeated until the paper surface is completely covered with colored pencil pigment.

1 Same as layering, except stem and shadow are left free of color.

2 Using medium to hard pressure, burnish all of the colors together with White, except the stem shadow, which should be burnished with Apple Green. Drag yellow into a portion of the highlight area with the White pencil, leaving it free of color. Drag color into the right edge of the apple, covering the paper surface.

3 Repeat layering for the second time, with the same colors as described in

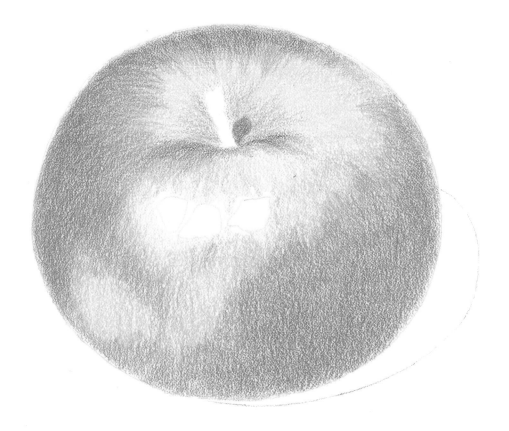

## Wax Bloom

The number one nemesis of colored pencil artists, mainly to those new to the medium, is a filmy residue that appears over heavily burnished and dark areas when using wax-based colored pencils. The "curse" of wax bloom can be handled in two ways: use oil-based colored pencils or spray artwork with workable fixative when it's completely finished. Several light coats of workable fixative not only remove wax bloom permanently, but return the art to its original luster and protect it from smudging.

# Burnishing

Step 1, omitting the 70% and 20% Greys. Layer directly on top of the white burnishing, graduating and blending the colors as they're layered over one another. To achieve the splotchy effect of the apple skin, use heavier strokes of colors one hue darker than the surrounding area.

Repeat burnishing with White and layering with the same colors as before,

exceptthis time, as each additional layer and burnish is added, begin deleting darker colors and White, still burnishing over the darker areas with lighter colors. For example, areas of darker red should be burnished with Poppy Red. Lighter red and orange areas should be burnished with Sunburst Yellow, and the remaining yellow areas with Canary Yellow. Continue until

the paper surface is completely covered and free of "specks." Redefine the stem shadow with Limepeel and Apple Green, if necessary.

Apply Light Peach, using medium pressure, to the entire stem, then apply Tuscan Red and accents of Warm Grey 70% on top.

The shadow is evenly layered with

Indigo Blue and Tuscan Red, lightly at first, then with increasing pressure as layers are added, until the surface is completely covered. The final layer should be Tuscan Red to indicate the apple's reflection on the shadow.

Using corresponding colors, clean up ragged edges with hard-lead colored pencils.

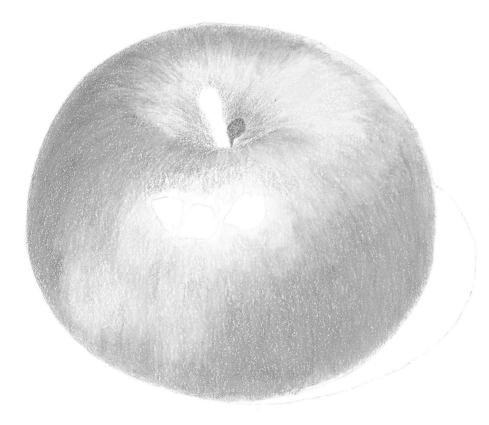

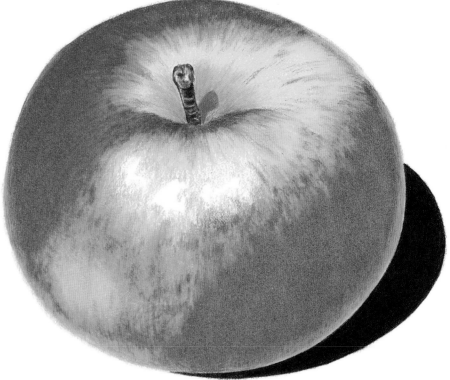

# Underpainting

Underpainting *(Wash)* serves a dual purpose: To color white paper without destroying its tooth, allowing it to be used to depict texture; to quickly cover the paper surface with pigment, decreasing the amount of time spent repeatedly layering and burnishing.

There are two basic methods of underpainting: Using water-soluble pencils thinned with a water wash or using wax/oil-based pencils washed with solvent. Both methods employ virtually the same method of layering at the onset, but instead of burnishing with white to cover the paper's surface, the colored pencil pigment is dissolved with either water or solvent, becoming a ground which will show through subsequent layering.

## Water Soluble Pencils

When using water soluble pencils, the layers of colored pencil are washed with a moderately wet, but not too wet, watercolor brush. It's advisable to use a small brush (for example, a no. 6) and wet only small areas at a time. Using a hair dryer set on high to dry the paper as rapidly as possible helps lessen paper warpage.

One way to produce texture on top of this ground is to lightly layer wax/oil pencils (without burnishing) over the underpainting using darker colors. Another type of texture can be created by unevenly layering water based pencil and/or water. This produces irregular dark and light areas that can be emphasized by layering wax/oil pencil over them.

## Wax/Oil-Based Pencils

A different effect can be accomplished by layering wax/oil-based pencils and blending them together with a solvent. As mentioned earlier, odorless turpentine, rubber cement thinner and colorless markers are the most frequently used solvents. Odorless turpentine and rubber cement thinner produce more evenly distributed color and washes than water soluble pencil, and

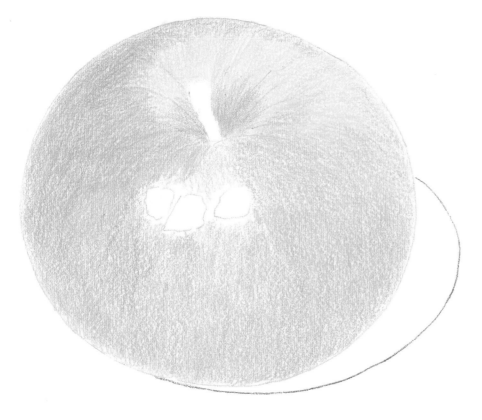

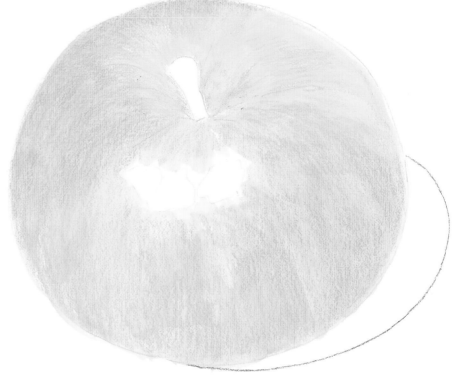

# Underpainting

colorless markers will produce pronounced streaks. The use of solvents offers more control of the wash, because they evaporate quickly (rubber cement thinner in particular).

## Combine With Burnishing

Colored pencil can be burnished over areas that have been underpainted with either water or solvents. When burnishing over an underpainted area, it doesn't matter whether the underpainting is light or dark.

Burnishing over underpainting will completely cover paper more quickly than just burnishing alone, but will offer less control over color and yield less intense hues.

## Removing Color

Areas underpainted with either water or solvent can be lightened (but not completely removed) easily with an kneaded eraser or an electric eraser equipped with an imbibed eraser strip. Pigment can be reapplied and washed or blended if necessary.

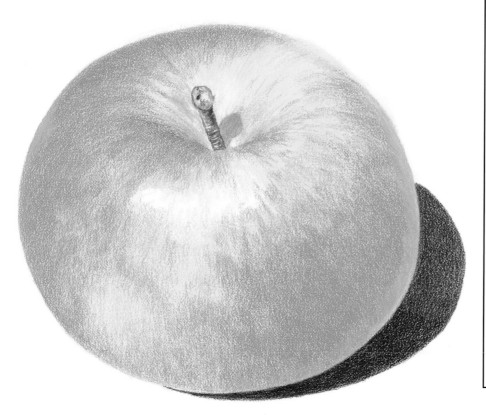

| Color Palette |
|---|
| (All colors are Prismacolors, except where noted: D=Derwent Watercolour Pencils, SWS = Design Spectracolor Watercolor Pencils) |
| May Green (D) |
| Zinc Yellow (D) |
| Lemon Yellow (SWS) |
| Canary Yellow (SWS) |
| Deep Cadmium (D) |
| Yellow Orange (D) |

**APPLE (BODY)**
Apple Green
Limepeel
Chartreuse
Yellow Chartreuse
Canary Yellow
Sunburst Yellow
Warm Grey 20%
Warm Grey 70%
Crimson Red
Scarlet Lake
Poppy Red
Pale Vermilion
Orange
White

**STEM**
Light Peach
Tuscan Red
Warm Grey 70%

**SHADOW**
Tuscan Red
Indigo Blue

## Water-soluble Pencils

1 Draw the apple, stem, contour and highlight area with a yellow hard-lead pencil, and the shadow line with a gray pencil.

Using medium pressure and following apple's contour, apply May Green to center and near the upper right edge of the apple. Graduate the center area outward in all directions, being careful to leave stem area free of pigment. Next, layer Lemon Yellow over Zinc Yellow in the upper right area of the apple; then layer Canary Yellow over Lemon Yellow from the right side to the upper left, leaving the right edge and highlight area free of pigment. Complete the apple by layering Deep Cadmium over Canary Yellow.

2 With a no. 6 watercolor brush, apply moderate to small amounts of water, starting at the stem area then working outward, constantly following the apple's contours. Bring some color into the right edge, but be careful not to paint the stem or highlight areas. Dry with hair dryer on high setting.

3 Same as Layering

# Underpainting With Solvents

To underpaint with solvents, use the same pencils/color palette in the *layering* and *burnishing* techniques.

1 Identical to Step 1 of Layering (see page 26), except more pressure should be used when applying color resulting in heavier coverage. The stem and shadow should be left free of color until Step 3. *Only* the greens and yellows are layered before blending with solvent.

2 With a cotton swab heavily saturated with rubber cement thinner (or turpentine), dissolve and blend the pigment together, following the apple's contours. Be sure to keep the cotton swab saturated as the solvent evaporates. Replace the cotton swab frequently, to prevent it from being "over blended" into one hue.

Apply the reds, etc., following Step 1 of the Layering demonstration on page 26, except use *less* pressure to keep the amount of red pigment to a minimum. The area of coverage should also be smaller, because red, if applied too heavily, will "over blend" into the yellow, resulting in the loss of the yellow area. Using *less* solvent than when blending yellows, blend reds together and into yellow areas. Replace swabs more frequently than when blending yellow. For smaller areas use watercolor brush of appropriate size with solvent.

3 Same as burnishing demonstration (page 28), with the following variance: do *not* burnish with white between layers.

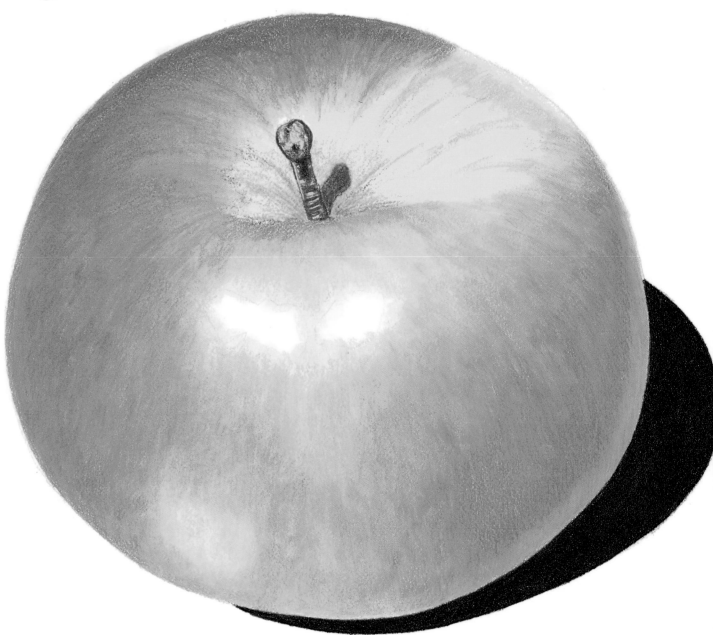

# Colorless Marker

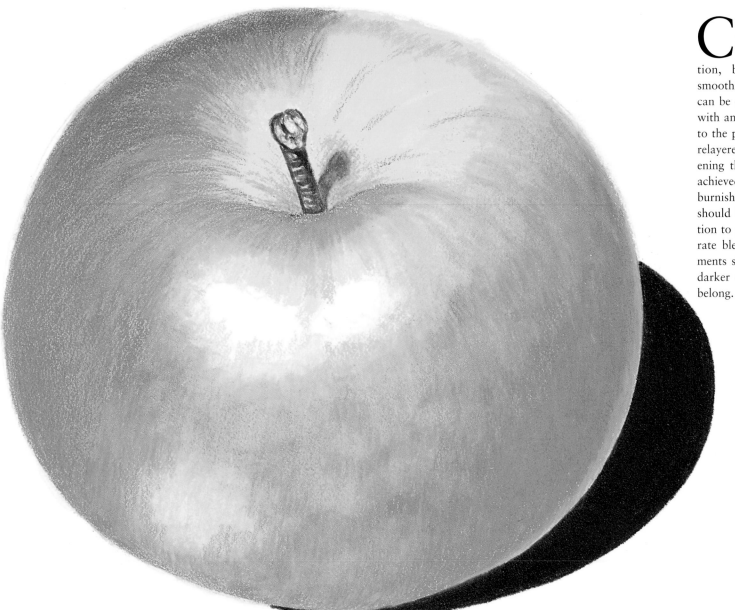

Colorless blenders can be substituted for solvents in step 2 of the underpainting with solvents demonstration, but the pigment doesn't blend smoothly, resulting in streaks. The streaks can be erased (unless this effect is desired) with an imbibed eraser, leaving a light tint to the paper surface. The colored pencil is relayered, blended and erased again, darkening the tint until the desired density is achieved. Color is then either layered or burnished over the tints. The marker nibs should be wiped clean after each application to prevent "over blending," and separate blenders for the yellow and red pigments should be used to prevent blending darker colors into areas where they don't belong.

# Water-Soluble Pencils

U sing all water soluble pencils entails the same processes as shown in the underpainting demonstration, except instead of using wax/oil-based pencils, water soluble pencils were used dry in Step 3.

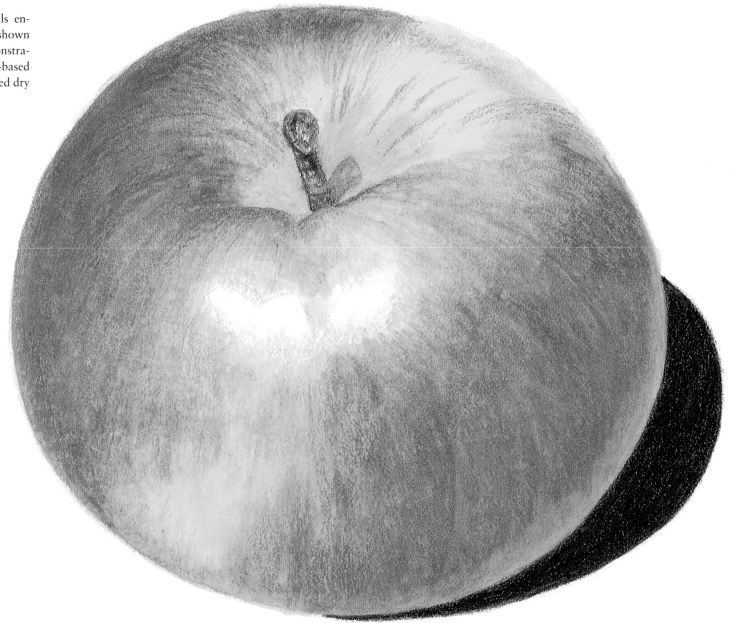

*Creating Textures in Colored Pencil*

# Linear Strokes

**S**trokes can be varied as shown by the use of, for example, a linear stroke.

---

**Be a Pioneer**

---

Use the techniques described in this section as a starting point — you could be a pioneering artist, inventing your own colored pencil techniques.

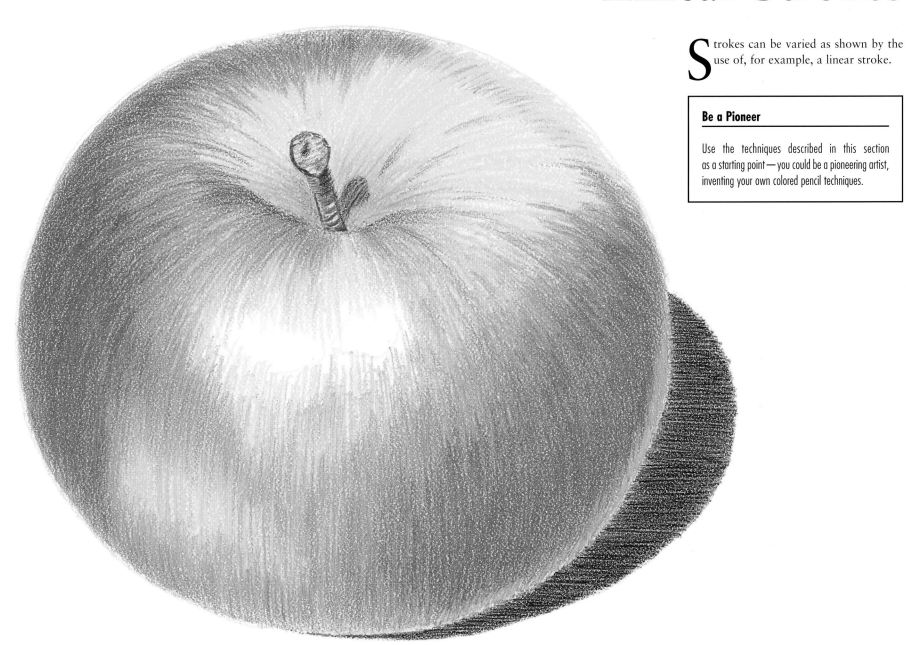

Part Three

# Natural Textures

These are important points to keep in mind before beginning: ∞ The purpose of this book is not to teach you how to paint roses, avocados, hood ornaments, etc., but how to paint their *textures*. Nor is it a book on composition or color theory. If you wish to use different colors or techniques, by all means do so. ∞ The subjects have been selected for their interest and applicability to creating other textures. For example, by learning how to create the texture of an orange, the texture of any citrus fruit can be created simply by changing the colors. ∞ The step-by-step explanations should be considered *guidelines*. They have been simplified in most cases. You may find it necessary to repeat steps or add/delete a color here or there. ∞ All colors in the palettes are Prismacolor pencils, except where noted. Feel free to substitute. ∞ Many of the texture studies use rubber cement thinner. You may substitute odorless turpentine or water soluble pencils. ∞ Don't get discouraged. Just like any other art form, the more you work at your art, the better you'll get. It may take several attempts to master these textures.

*Bell Peppers, 25" x 38"*

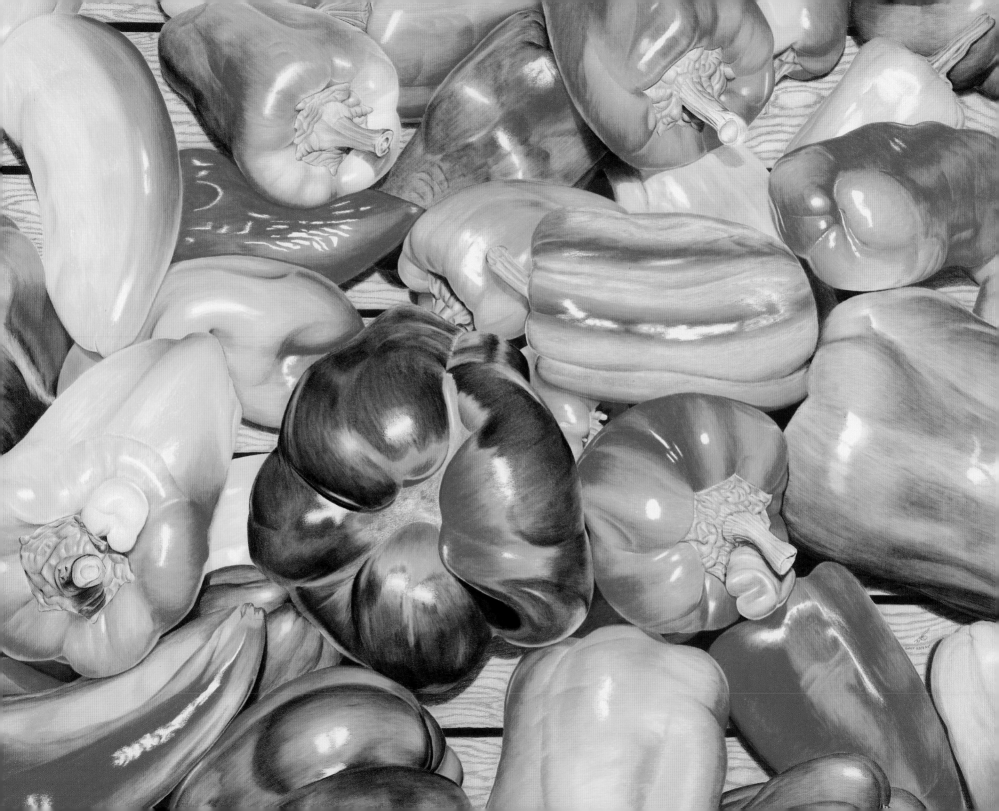

# Rose

This photograph of a yellow-orange rose will reveal, under close scrutiny, a wealth of subtle hues too numerous to describe individually. By layering and burnishing various combinations of colored pencil, much of their subtle beauty can be attained. The color palette is listed (as always), starting with the first color layered on the paper surface, usually the darkest, to the last, usually the lightest or "burnishing" color.

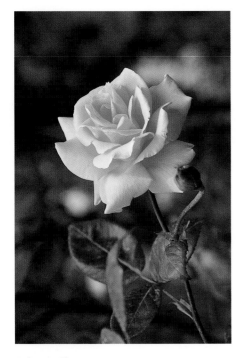

Reference Photo

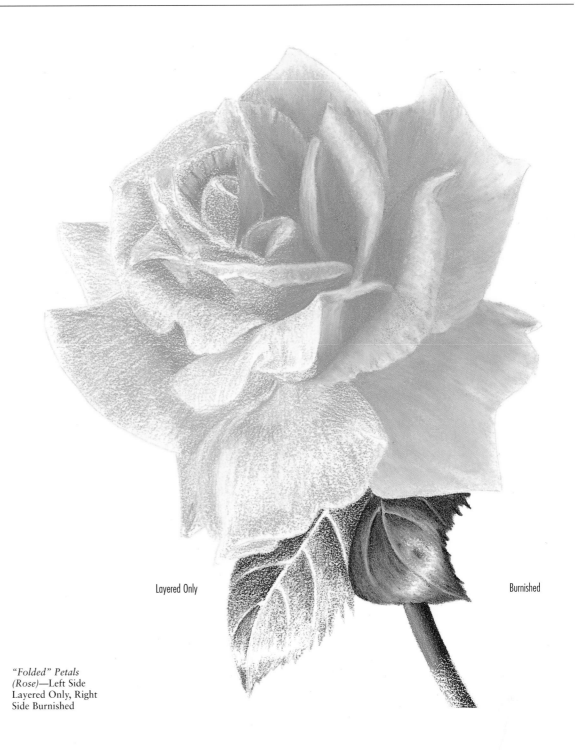

Layered Only

Burnished

*"Folded" Petals (Rose)*—Left Side Layered Only, Right Side Burnished

# Rose

## Typical Rose Petal Layering

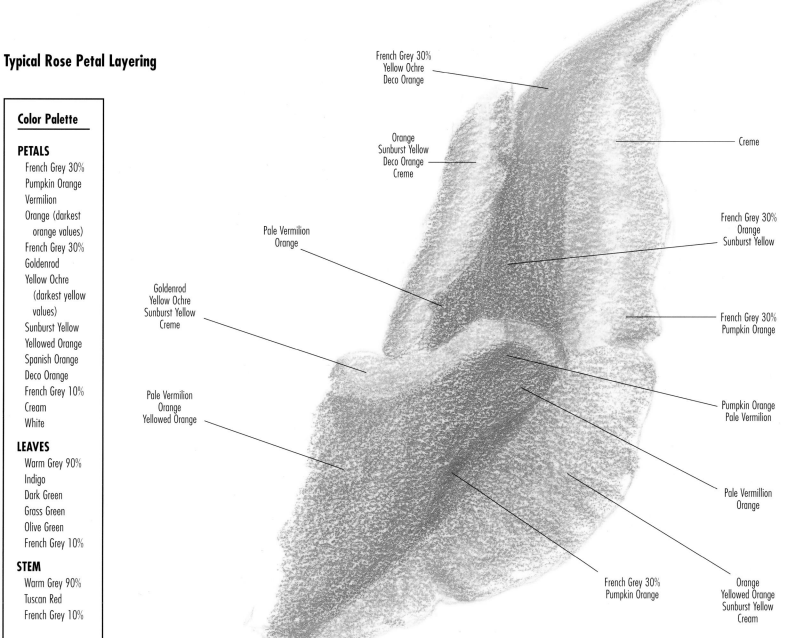

### Color Palette

**PETALS**
French Grey 30%
Pumpkin Orange
Vermilion
Orange (darkest orange values)
French Grey 30%
Goldenrod
Yellow Ochre (darkest yellow values)
Sunburst Yellow
Yellowed Orange
Spanish Orange
Deco Orange
French Grey 10%
Cream
White

**LEAVES**
Warm Grey 90%
Indigo
Dark Green
Grass Green
Olive Green
French Grey 10%

**STEM**
Warm Grey 90%
Tuscan Red
French Grey 10%

French Grey 30%
Yellow Ochre
Deco Orange

Orange
Sunburst Yellow
Deco Orange
Creme

Creme

French Grey 30%
Orange
Sunburst Yellow

Pale Vermilion
Orange

Goldenrod
Yellow Ochre
Sunburst Yellow
Creme

French Grey 30%
Pumpkin Orange

Pale Vermilion
Orange
Yellowed Orange

Pumpkin Orange
Pale Vermilion

Pale Vermillion
Orange

French Grey 30%
Pumpkin Orange

Orange
Yellowed Orange
Sunburst Yellow
Cream

# Cineraria

**W**hy paint daisies when this flower offers far more exciting color? This example demonstrates how to paint flowers with smooth regular petals and "busy" centers.

Reference Photo

## Color Palette

**STEM**

Warm Grey 70%

Dark Green

Olive Green

Apple Green

Cream

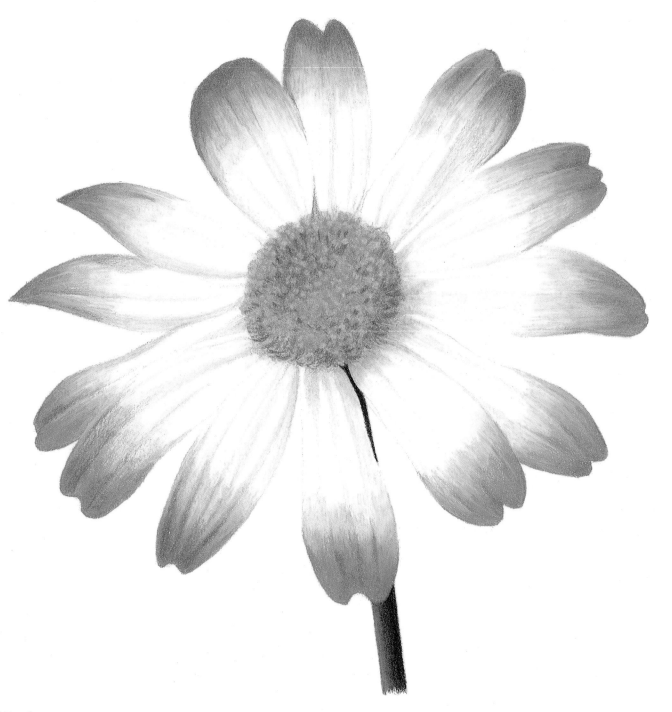

# Cineraria

**Center**

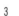

1

2

3

4

5

6

**1** Layer Cool Grey 20% and Sunburst Yellow.

**2** Wash with rubber cement thinner and a cotton swab.

**3** Layer Magenta and Carmine Red.

**4** Dab with rubber cement thinner and a cotton swab.

**5** Erase with a sharpened imbibed eraser in an electric eraser.

**6** Lightly burnish with Magenta, Carmine Red, Tuscan Red and Sunburst Yellow. Dab center with a nearly dry cotton swab and rubber cement thinner.

---

**Color Palette**

**CENTER**

Sunburst Yellow
Cool Grey 20%
Magenta
Carmine Red

# Cineraria

## Petals

1 Layer Cool Gray 20% and 10%.

2 Wash with rubber cement thinner and cotton swab.

3 Layer Magenta, Process Red, Carmine Red, Cool Grey 20% and 10%.

4 Wash with rubber cement thinner and cotton swab from white to red. Do not allow red into white area of petal.

5 Relayer Magenta, Process Red and Carmine Red.

6 Burnish with White (white area), Carmine Red and White (red area).

---

**Color Palette**

**PETALS**
Cool Grey 10%
Cool Grey 20%
Cool Grey 30%
Magenta
Process Red
Carmine Red
White

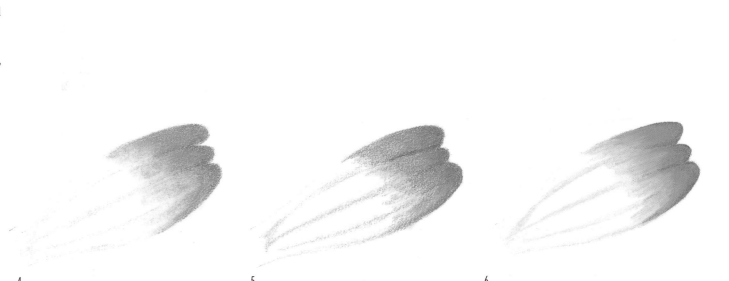

1       2       3

4       5       6

# Tulip

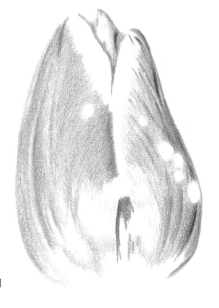

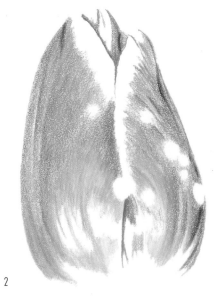

Like the rose, there are many subtle contours and colors in this smooth textured tulip bulb. Be certain to let the paper show through for the highlight areas.

1 Following contours of bulb, layer Cool Grey 70%, Tuscan Red, Crimson Lake, Crimson Red, Magenta, Carmine Red and Cream. Leave paper free of layering in highlight areas.

2 Burnish with White except in the darkest areas.

3 Relayer Crimson Lake and Crimson Red, Magenta, Carmine Red and Cream.

4 Reburnish with White and Carmine Red. In White areas, layer Cool Grey 20%, then burnish and drag with White. Add variegations in White area with strokes of Crimson Red layered with Carmine Red, then lightly burnish with White. Layer stem with Olive Green, Light Yellow Green, Apple Green, Cool Grey 20% and Cream.

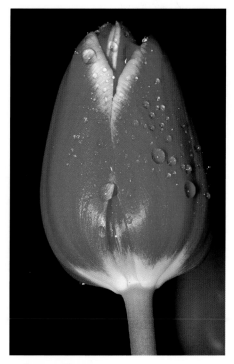

**Color Palette**

**BULB**
Cool Grey 70%
Tuscan Red
Crimson Lake
    (Spectracolor)
Crimson Red
Magenta
Carmine Red
Cream
Cool Grey 20%
White

**STEM**
Olive Green
Light Yellow Green
Apple Green
Cool Grey 20%
Cream

Reference Photo

# Orchid

Orchids come in a multitude of sizes, shapes and colors. This subject was chosen for its variegations.

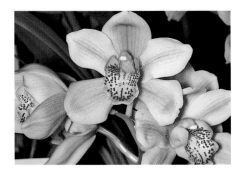

Reference photo

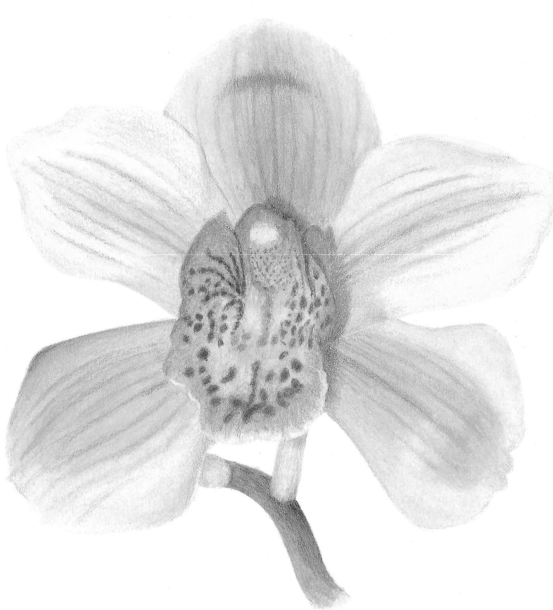

**Color Palette**

**CENTER**
Jasmine
French Grey 30%
Goldenrod
Henna
Raspberry
Hot Pink
Pink
Peach
Sunburst Yellow
White

**PETALS**
Jasmine
Peach
Light Peach
Deco Peach
Hot Pink
Deco Pink
Raspberry

**STEM**
Dark Green
Olive Green
Apple Green
French Grey 30%
Cream
French Grey 10%

# Orchid

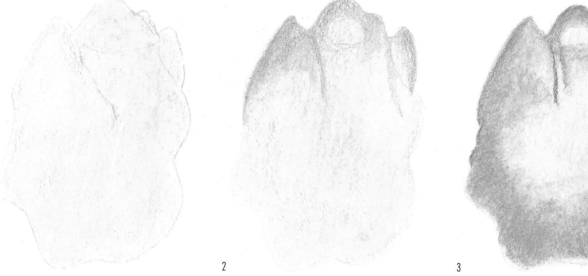

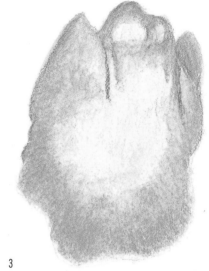

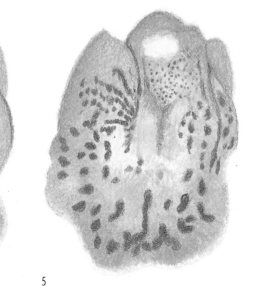

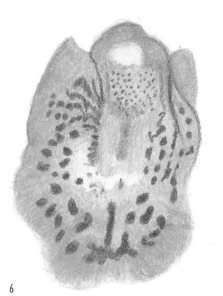

## Center

1 Layer Jasmine. Wash with rubber cement thinner and cotton swab.

2 Layer French Grey 30% and Goldenrod. Wash with rubber cement thinner and a small watercolor brush.

3 Layer Henna, Raspberry, Hot Pink, Pink, Peach and Goldenrod. Wash with rubber cement thinner and a small watercolor brush.

4 Layer Sunburst Yellow and Goldenrod. Wash with rubber cement thinner and a cotton swab. Relayer colors in steps 1, 2 and 3, as necessary. Lightly erase the highlight area with a sharpened imbibed eraser and electric eraser. Lightly burnish highlight with Jasmine and White.

5 Burnish spots with Henna, using heavy pressure.

6 Dab spots with rubber cement thinner and a small watercolor brush.

# Orchid

## Petals

1 Layer Peach, Light Peach, Deco Peach and Jasmine. Wash with rubber cement thinner and a cotton swab.

2 Layer Hot Pink, Pink and Peach. Wash with rubber cement thinner and a cotton swab. Lightly erase highlight area with kneaded eraser.

3 Layer Raspberry. Wash with rubber cement thinner and a cotton swab.

4 Layer Raspberry.

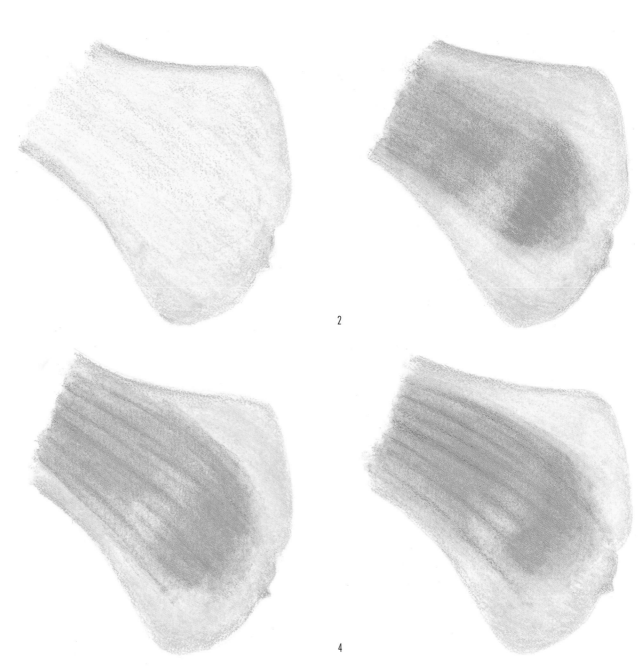

1

2

3

4

# Hyacinth

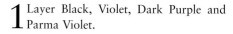

The hyacinth exemplifies multi-bloom flowers. Do not attempt to put every flower in your painting, but enough to give a "clumping" effect.

**1** Layer Black, Violet, Dark Purple and Parma Violet.

**2** Wash with rubber cement thinner and a medium-small watercolor brush or cotton swab.

**3** Burnish with White, except in darkest areas.

**4** Burnish with Black, Violet, Parma Violet and White.

1

2

3

4

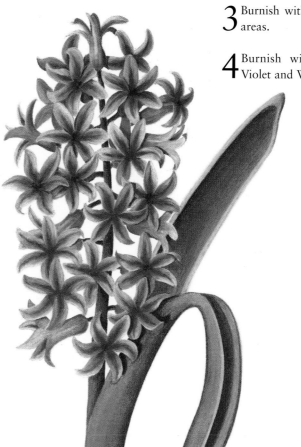

**Color Palette**

**FLOWERS**
Violet
Dark Purple
Parma Violet
Violet Blue
White

**FOLIAGE**
Warm Grey 90%
Dark Green
Olive Green
Apple Green
Cream

# Marigold

The marigold's two-tiered coloring lends itself to colored pencil painting with water and solvents.

## Color Palette

**FLOWER**

Middle Chrome
Deep Cadmium
   (Derwent
   Watercolour
   pencils)
Tuscan Red
Crimson Lake
   (Spectracolor)
Crimson Red
Scarlet Lake
Poppy Red
Yellow Ochre
White (center
   "berries" only)

**LEAVES**

Warm Grey 70%
Dark Green
Olive Green
Cream

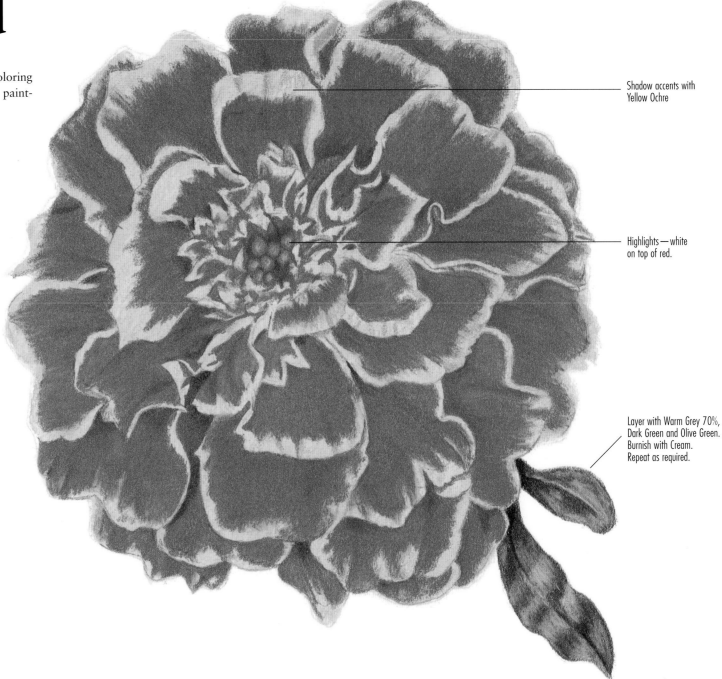

Shadow accents with
Yellow Ochre

Highlights—white
on top of red.

Layer with Warm Grey 70%,
Dark Green and Olive Green.
Burnish with Cream.
Repeat as required.

# Marigold

## Petals

**1** Layer entire flower with Middle Chrome and Deep Cadmium.

**2** Wash with water. Relayer with Middle Chrome and Deep Cadmium. Rewash.

**3** Layer with Tuscan Red, Crimson Lake, Crimson Red, Scarlet Lake and Poppy Red.

**4** Wash with rubber cement thinner and a medium-small watercolor brush.

**5** Burnish with Scarlet Lake (darkest areas only) and Poppy Red.

**6** Wash with rubber cement thinner and a medium-small watercolor brush.

# Orange

The tooth of the paper surface was used to help capture the texture of the orange's skin.

**1** Layer French Grey 30%, French Grey 20% and French Grey 10%. Wash with rubber cement thinner and cotton swab.

**2** Layer Orange Chrome and Naples Yellow. Wash with water and a medium watercolor brush.

**3** Layer Pumpkin Orange, Orange and Yellowed Orange. On the stem, layer and burnish Goldenrod, Olive Green, Light Umber and Cream.

**Color Palette**

**SKIN**
French Grey 30%
French Grey 20%
French Grey 10%
Orange Chrome
  (Derwent
  Watercolour
  Pencil)
Naples Yellow
  (Derwent
  Watercolour
  Pencil)
Pumpkin Orange
Orange
Yellowed Orange

**STEM**
Goldenrod
Olive Green
Light Umber
Cream

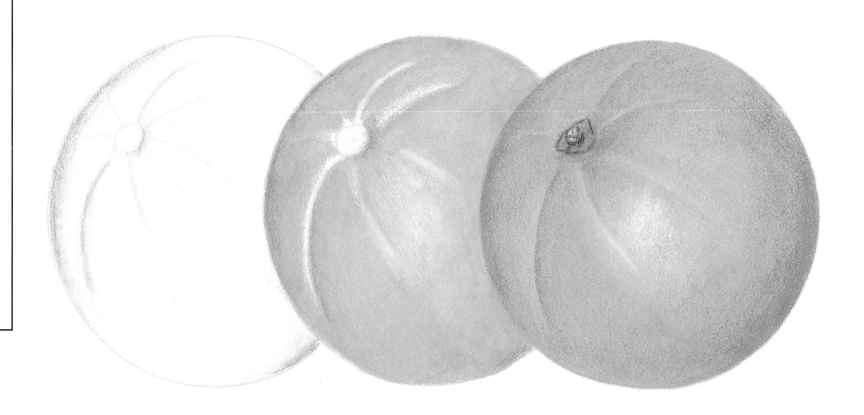

# Grapes

**Color Palette**

**BODY**
Black Grape
Dark Purple
Tuscan Red
Raspberry
Henna
Sunburst Yellow
White
Tuscan Red
 (Verithin)
Purple (Verithin)

**STEM**
Apple Green
Light Umber
Cream

The "frosted" texture is depicted by randomly burnishing with white in the final step.

**1** Layer Black Grape, Dark Purple, Tuscan Red, Raspberry, Henna and Sunburst Yellow. Leave the highlight area free of color throughout process.

**2** Burnish with White.

**3** Layer/burnish Tuscan Red, Raspberry, Henna and Sunburst Yellow. Amounts of these colors should be varied, since no two grapes are exactly alike.

**4** Burnish with White randomly. Sharpen edges with Tuscan Red or a Purple Verithin.

# Strawberry

S trawberry seeds offer somewhat of a challenge to paint, but it's well worth the effort.

## Leaves

Layer Warm Grey 90%, Dark Green, Grass Green, Dark Green, Olive Green and Apple Green. Burnish with Cream in the lighter areas and Apple Green in the darker areas. Sharpen edges with Olive Green Verithin.

### Color Palette

**BODY**

Jasmine
Burnt Yellow Ochre (Derwent Watercolour Pencil)
Tuscan Red
Crimson Lake (Spectracolor)
Crimson Red
Scarlet Lake
Poppy Red
Carmine Red (Verithin)
White

**LEAVES**

Warm Grey 90%
Dark Green
Grass Green
Dark Green
Olive Green
Apple Green
Cream
Olive Green (Verithin)

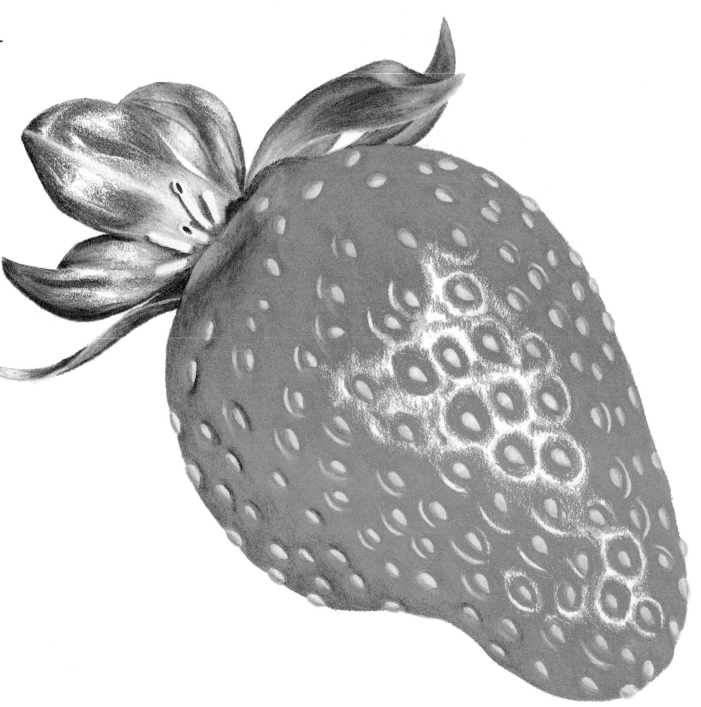

# Strawberry

1 Burnish seeds with Jasmine. Wash with rubber cement thinner and a small brush.

2 Layer Tuscan Red, Crimson Lake, Crimson Red, Scarlet Lake and Poppy Red. Leave the highlight areas free of color throughout process.

3 Burnish with White; do not apply White to seeds.

4 Layer/burnish Scarlet Lake and Poppy Red. Sharpen seeds with Carmine Red Verithin. Add shadows to the seeds with Burnt Yellow Ochre.

1

2

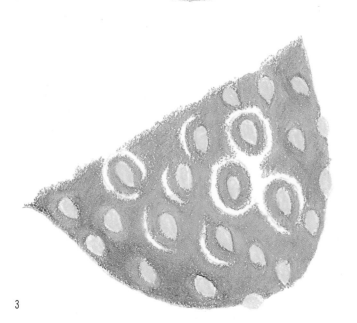

3

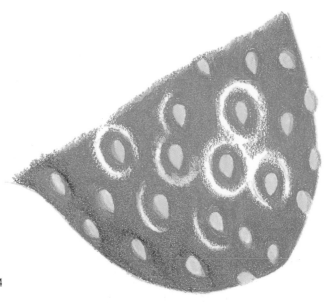

4

*Creating Textures in Colored Pencil*

# Banana

**Color Palette**

**BODY**
French Grey 20%
French Grey 10%
Yellow Chartreuse
Canary Yellow
   (Lyra)
Canary Yellow
   (Spectracolor)
Cream

**SPOTS**
French Grey 90%
Sepia
Dark Brown

1 Layer French Grey 20%, 10% and Yellow Chartreuse. Wash with rubber cement thinner and a cotton swab. Leave highlight clear until step 3.

2 Layer Canary Yellow (Lyra) and Canary Yellow (Spectracolor).

3 Wash with rubber cement thinner and a cotton swab. Burnish with Cream. For the spots, layer/burnish French Grey 90%, Sepia and Dark Brown. Dab with rubber cement thinner and a cotton swab.

# Peach

To achieve the "fuzzy" texture, the final layer of color is wiped with a dry cotton swab instead of burnished.

1 Layer Spanish Orange, Yellowed Orange, Orange and Pumpkin Orange.

2 Wash with rubber cement thinner and a cotton swab.

3 Layer Crimson Lake, Crimson Red, Pale Vermilion and Pumpkin Orange. Burnish lightly with dry cotton swab. Relayer same colors. For the stem, burnish Jasmine and Light Umber. Wash with rubber cement thinner and a cotton swab. Burnish Jasmine, Raw Umber and Dark Brown Verithin.

## Color Palette

**BODY**

Spanish Orange
Yellowed Orange
Orange
Pumpkin Orange
Crimson Lake
   (Spectracolor)
Crimson Red
Pale Vermilion

**STEM**

Jasmine
Light Umber
Dark Brown
   (Verithin)
Raw Umber

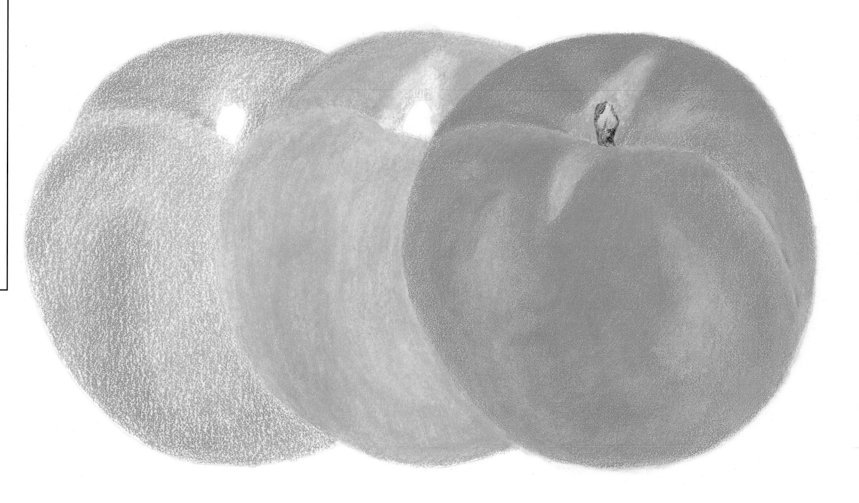

# Tomato

**1** Layer Crimson Lake, Crimson Red, Scarlet Lake, Poppy Red and Pale Vermilion. Leave the highlight areas free of color throughout process.

**2** Burnish with White.

**3** Layer/burnish Scarlet Lake, Poppy Red and Pale Vermilion (except lightest areas).

**4** Burnish with Pale Vermilion. Sharpen edge with Carmine Red Verithin. For the stem, layer Warm Grey 90%, Dark Green, Olive Green and Goldenrod. Burnish with Cream. Layer Olive Green. Reburnish with Cream. Sharpen edge with Olive Green Verithin.

Center—Layer Goldenrod. Wash with rubber cement thinner and small brush. Layer Light Umber.

| Color Palette |
| --- |
| **BODY** |
| Crimson Lake (Spectracolor) |
| Crimson Red |
| Scarlet Lake |
| Poppy Red |
| Pale Vermilion |
| White |
| Carmine Red (Verithin) |
| **STEM** |
| Warm Grey 90% |
| Dark Green |
| Olive Green |
| Goldenrod |
| Cream |
| Olive Green (Verithin) |
| **CENTER** |
| Goldenrod |
| Light Umber |

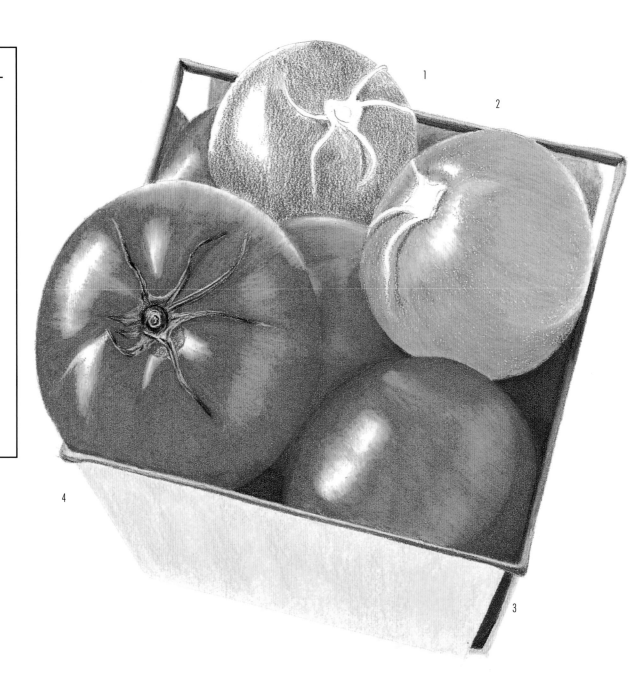

# Avocado

The rough, bumpy texture is depicted by layering with circular strokes and dabbing with rubber cement thinner and a kneaded eraser.

1 Layer using circular strokes, layer Warm Grey 90%, Dark Green and Peacock Green.

2 Dab with rubber cement thinner and a cotton swab held perpendicular to surface.

3 Dab with kneaded eraser, kneading it frequently as color builds on the eraser. Relayer Warm Grey 90%, Dark Green and Peacock Green. Dab with rubber cement thinner and a cotton swab held perpendicular to surface, as in Step 2. For the stem, layer/burnish Dark Brown (Verithin), Sienna Brown, Burnt Ochre and Goldenrod. Wash with rubber cement thinner and a small brush.

**Color Palette**

**BODY**
Warm Grey 90%
Dark Green
Peacock Green

**STEM**
Dark Brown
  (Verithin)
Sienna Brown
Burnt Ochre
Goldenrod

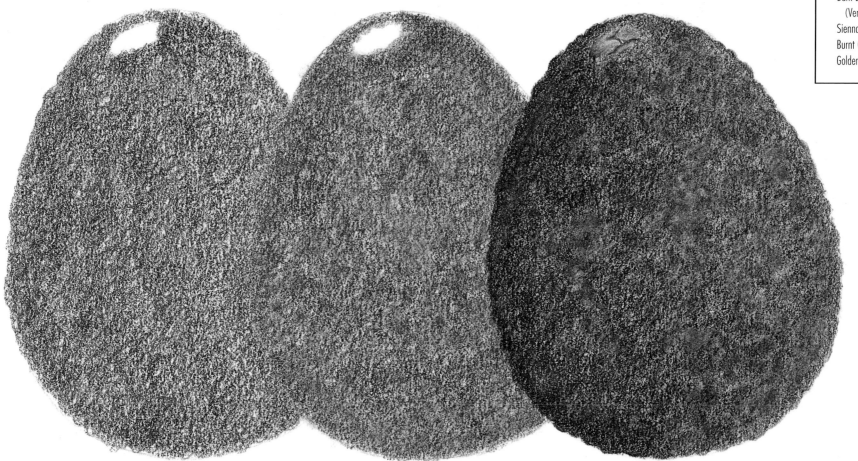

# Onion

The papery, translucent onion skin can be easily painted with colored pencil.

1 Draw surface lines with Dark Brown Verithin pencil. Be sure to keep pencil sharp.

2 Layer Burnt Ochre, Pumpkin Orange and Mineral Orange. Leave the high-light areas free of color until Step 3.

3 Wash with rubber cement thinner and a cotton swab, dragging some color into highlight area. Retouch every other surface line with Pumpkin Orange and Dark Brown Verithin. Burnish areas adjacent to highlight with Jasmine.

   Burnish "skinless" areas (at bottom of onion) with Chartreuse and Cream. Wash with rubber cement thinner and a cotton swab.

---

**Color Palette**

---

Dark Brown
   (Verithin)
Burnt Ochre
Pumpkin Orange
Mineral Orange
Jasmine
Chartreuse
Cream

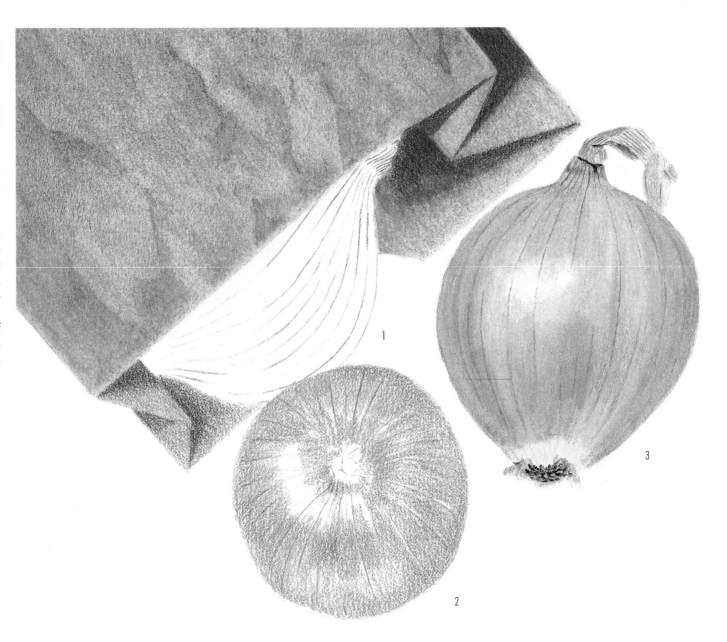

# Potato

**Color Palette**

Raw Sienna
(Derwent
Watercolour)
French Grey 30%
Jasmine
Light Umber

If painted properly, the dull, rough texture of the potato will look so real that you might be tempted to poke holes in it and put it in the oven!

1 Layer and wash Raw Sienna with water and a medium brush, for darker values. Layer French Grey 30% on top of Raw Sienna and wash with rubber cement thinner and a cotton swab.

2 Layer entire area with Jasmine.

3 Wash with rubber cement thinner and a cotton swab.

4 Layer with Light Umber, using circular strokes of varying density. Use both sharp and flat point. Drag small amounts of Light Umber into lighter areas with rubber cement thinner and a small brush.

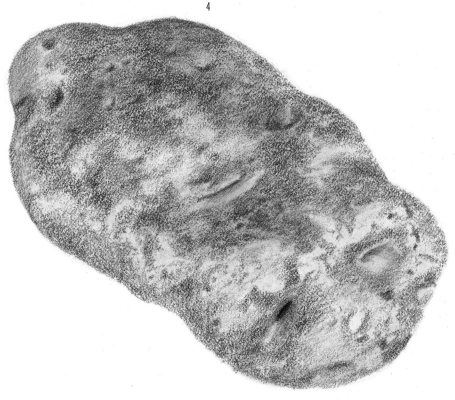

# Indian Corn

Similarly colored kernels may vary in hue somewhat. This can be depicted by increasing or decreasing the amount of color applied. Be sure to leave the highlight areas free of color throughout the painting process.

## Husk

**1** Layer with Jasmine. Wash with rubber cement thinner and a cotton swab.

**2** Layer with French Grey 20%. Wash with rubber cement thinner and a small brush.

**3** Erase areas adjacent to French Grey 20% with an imbibed eraser in an electric eraser.

**4** Layer with Light Umber. Wash with rubber cement thinner and a small brush. Burnish lightly with White. Rewash with rubber cement thinner and a small brush.

**5** Draw lines with Jasmine and Gold Verithin.

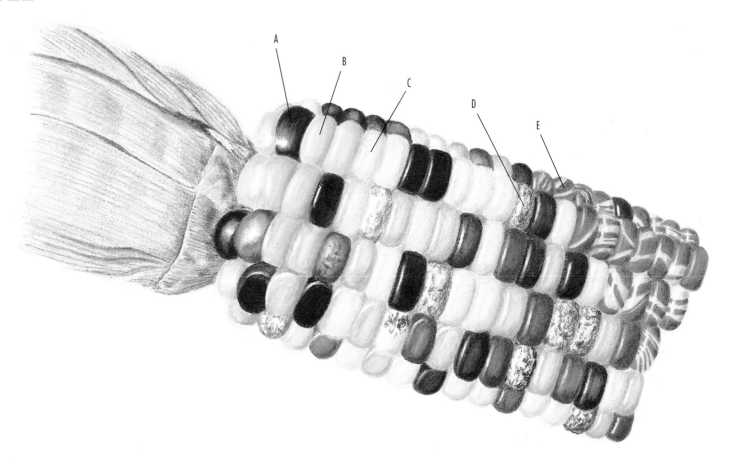

1         2         3         4         5

# Indian Corn

## A—Purple Kernel

**1** Layer Black Grape, Tuscan Red and Dark Purple.

**2** Burnish Black Grape, Tuscan Red and Dark Purple.

**3** Burnish with White. Sharpen edges/highlight area with Tuscan Red Verithin.

Color can be varied by increasing, decreasing or deleting one of the three colors.

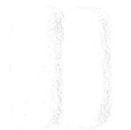

A

## B C D E—Base Color

**1** Layer French Grey 20% and 10%.

**2** Wash with rubber cement thinner and a small brush.

## B—Yellow Kernel

**3** Layer with Sunburst Yellow. Wash with rubber cement thinner and a small brush.

**4** Burnish with White or Cream. Sharpen edges/highlight area with Yellow Ochre Verithin.

## C—White Kernel

**3** Layer with Cream. Wash with rubber cement thinner and a small brush.

**4** Burnish with White.

## D—Speckled Kernel

**3** Layer randomly with Tuscan Red or Black Grape.

## E—Striped Kernel

**3** Layer with Cream. Wash with rubber cement thinner and a small brush.

**4** Layer/burnish Tuscan Red and Crimson Lake. Sharpen edges/highlight area with Carmine Red Verithin.

BCDE

B

C

D

E

# Maple Leaf

This maple leaf is depicted in three visually distinct seasonal stages.

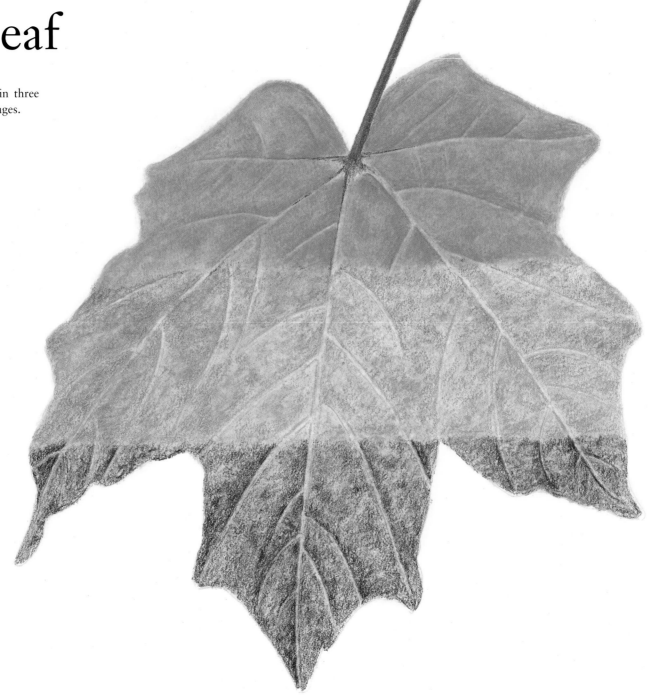

# Maple Leaf

## Spring

**1** Layer Sunburst Yellow. Wash with rubber cement thinner and a cotton swab.

**2** Layer Apple Green, Light Yellow Green and Chartreuse. Wash with rubber cement thinner and a small brush.

**3** Layer/burnish with Light Yellow Green and Chartreuse.

## Autumn

**4** Layer Sunburst Yellow and Goldenrod. Wash with rubber cement thinner and a cotton swab.

**5** Lightly layer randomly Orange and Light Yellow Green. Dab with rubber cement thinner and a small brush.

**6** Lightly layer randomly Orange, Light Yellow Green and Poppy Red.

## Late Autumn

**7** Layer Light Umber. Wash with rubber cement thinner and a small brush.

**8** Randomly layer Dark Brown, Pumpkin Orange and Terra Cotta. Dab lightly with rubber cement thinner and brush.

**9** Randomly layer Dark Brown, Pumpkin Orange, Terra Cotta and Sunburst .

# Philodendron Leaf

Reflective objects like this philodendron leaf are best shown by burnishing and permitting the white surface to show through the burnished layers of colored pencil.

**Color Palette**

Grass Green
Olive Green
Real Green
  (Spectracolor)
Apple Green
Light Yellow Green
White

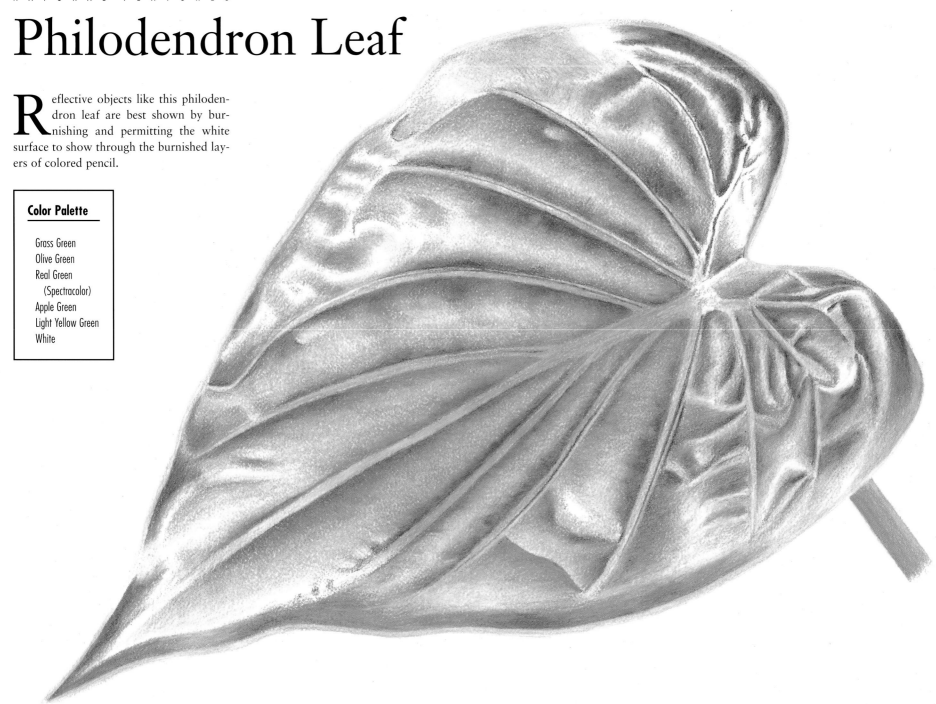

# Philodendron Leaf

**1** Layer Grass Green and Olive Green.

**2** Layer Real Green.

**3** Layer Apple Green and Light Yellow Green.

**4** Burnish with White.

**5** Layer/burnish Grass Green, Olive Green, Real Green, Apple Green and Light Yellow Green. Repeat layering/burnishing as required.

1

2

3

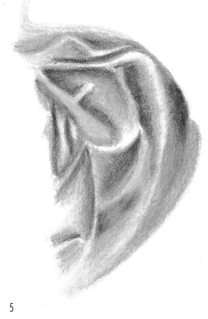

4

5

# Croton

Croton and coleus leaves, along with other indoor plants, make colorful and interesting subjects.

1 Layer Spanish Orange and Yellowed Orange. Wash with rubber cement thinner and a cotton swab.

2 Layer Scarlet Lake and Poppy Red. Dab with rubber cement thinner and a small brush. Repeat layering.

3 Randomly layer/burnish Warm Grey 90%. Layer/burnish Grass Green and Dark Green. Layer/burnish, as required, Spanish Orange, Scarlet Lake and Poppy Red. Sharpen edges of green and red areas with Green and Carmine Red Verithins.

---

**Color Palette**

---

**LEAF**
Spanish Orange
Yellowed Orange
Scarlet Lake
Poppy Red
Warm Grey 90%
Dark Green
Grass Green
Green (Verithin)
Carmine Red
   (Verithin)

**STEM**
Apple Green
Crea

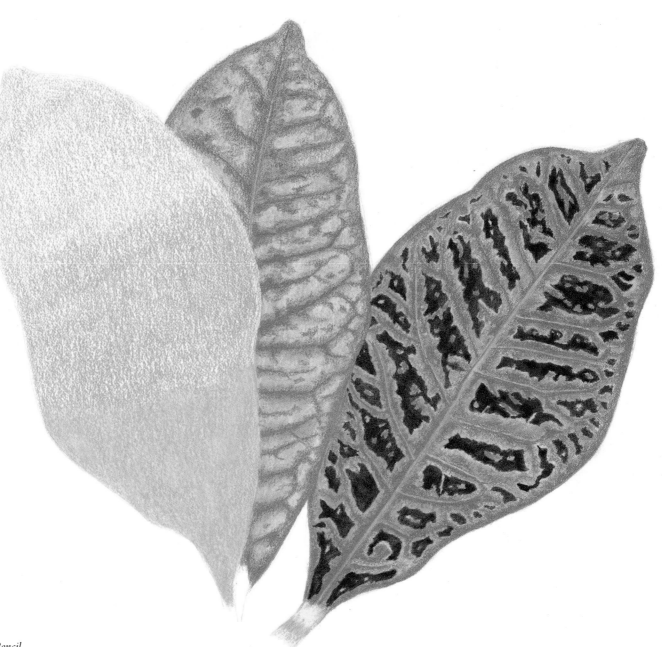

# Kale Leaf

Y ou must really study and under-
stand the subject to successfully
paint leaves like this, but once their
"anatomy" is understood, painting them
can be an engrossing and rewarding
process.

**1** Layer Mulberry, Process Red and
Tuscan Red (shadow areas only).

**2** Layer Warm Grey 90% and Olive
Green (in shadow areas only).

**3** Layer Olive Green, Grass Green and
Limepeel.

**4** Burnish Step 1 with White (except
shadow areas). Layer/burnish Process
Red.

**5** Wash Step 3 with rubber cement thin-
ner and a small brush. Do not wash
shadow areas.

**6** Burnish Step 2 with Olive Green.

**7** Lightly burnish Step 5 with Cream.

**8** Repeat layering/burnishing Olive
Green, Grass Green and Limepeel.

**9** Sharpen edges with Olive Green
Verithin. Draw edges with Rose
Verithin.

**Color Palette**

**PETALS**
Mulberry
Process Red
Tuscan Red
Warm Grey 90%
Olive Green
Grass Green
Limepeel
White
Cream
Rose Verithin

# Fir and Palm

## Douglas Fir Needles

The steps are shown progressively left-to-right/top-to-bottom. Note the use of Indigo Blue for the darker values.

**1** Layer Indigo Blue (lower only), Dark Green, Olive Green and Limepeel.

**2** Burnish Cream, Grass Green, Olive Green, Limepeel and Warm Grey 90% (Lower only). Sharpen edges with Green Verithin.

## Branch

**3** Layer Goldenrod.

**4** Wash with rubber cement thinner and a small brush.

**5** Layer Light Umber.

**6** Layer/burnish Dark Green Verithin.

## Palm Leaves

Steps are shown top to bottom.

**1** Layer Dark Green and Apple Green.

**2** Lightly burnish White.

**3** Burnish Dark Green and Apple Green.

**4** Sharpen edges with Green Verithin.

**5** Burnish Goldenrod and Light Umber to random tips.

**6** Burnish Dark Green and Limepeel to branch as shown.

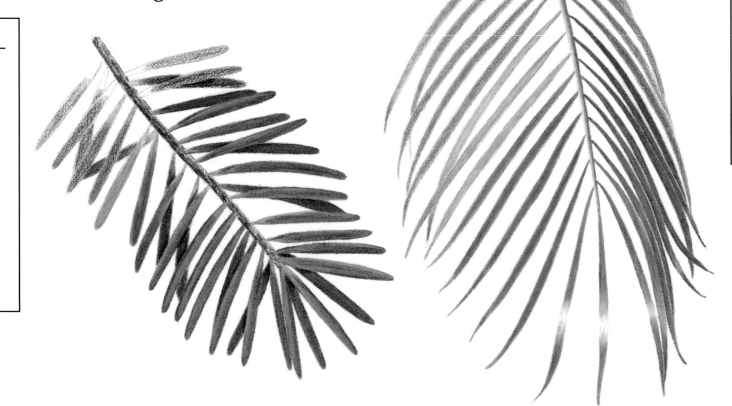

---

### Fir Palette

**NEEDLES**

Indigo Blue
Dark Green
Olive Green
Limepeel
Cream
Grass Green
Warm Grey 90%
Green (Verithin)

**BRANCH**

Goldenrod
Dark Brown
  (Verithin)
Light Umber

---

### Palm Palette

Dark Green
Apple Green
White
Green (Verithin)
Goldenrod
Light Umber
Limepeel (branch
  only)

---

# Cactus

## Color Palette

**BODY**

Warm Grey 90%
Grass Green
Olive Green
Light Yellow Green
True Green

**NEEDLES**

Cool Grey 20%
White (Verithin)
Yellow Ochre
(Verithin)
Black (Verithin)
Dark Brown
(Verithin)
Terra Cotta
(Verithin)

**BUDS**

Cool Grey 20%
Yellowed Orange
Sunburst Yellow
Olive Green
Light Yellow Green

**FLOWER**

Cool Grey 20%
Orange
Yellowed Orange
Sunburst Yellow
White
Pumpkin Orange
Canary Yellow
Orange (Verithin)

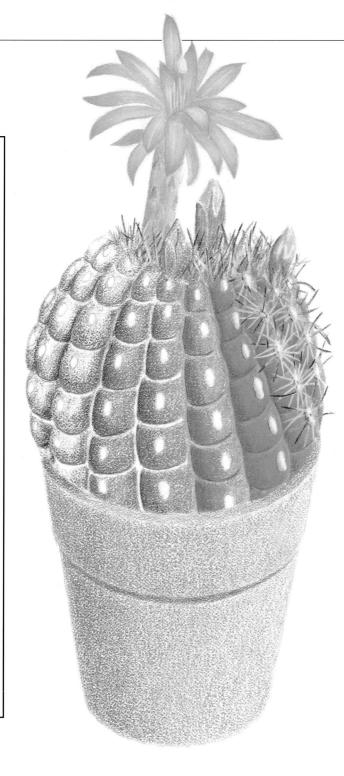

Cacti come in vast varieties. Needles are best rendered by *gently* scraping away layers of colored pencil with an X-Acto knife. Replace the blade when it starts to "drag".

## Body

1 Layer Warm Grey 90%, Grass Green, Olive Green, Light Yellow Green and True Green. Leave areas free of color as shown.

2 Burnish White (not darkest values), then Light Yellow Green and True Green, Olive Green (darkest area only), Cool Grey 20% and White (needle center).

3 Lightly scratch needles on body with a no. 16 X-Acto knife. Burnish with White Verithin and randomly color with Yellow Ochre, Black and Dark Brown Verithin.

## Buds

4 Layer Cool Grey 20%. Wash with rubber cement thinner and a small brush.

5 Layer Yellowed Orange and Sunburst Yellow. Wash with rubber cement thinner and a small brush.

6 Layer Olive Green, Light Yellow Green and True Green. Wash with rubber cement thinner.

## Flower

7 Layer Cool Grey 20% (left side of stem, stamen, petal shadow areas). Wash with rubber cement thinner and a small brush.

8 Layer Orange, Yellowed Orange to stem. Wash with rubber cement thinner. Lightly burnish White and Cool Grey 20%.

9 Add green triangles to stem by layering/burnishing Light Yellow Green, Cool Grey 20% (darker values) and White (lighter values).

10 Layer Orange (tips of petals). Wash with thinner and a small brush.

11 Layer Petals with Yellowed Orange and Sunburst Yellow. Burnish White, Yellowed Orange and Sunburst Yellow.

12 Lightly burnish petal tips with Pumpkin Orange. Sharpen edges with Orange Verithin.

13 Layer stamen with Canary Yellow. Burnish with White.

14 Scratch smaller stamen with X-Acto knife. Burnish with White Verithin.

15 Add top needles with strokes of Terra Cotta, Dark Brown, Black and Yellow Ochre Verithin. Scratch additional as required.

# Bark

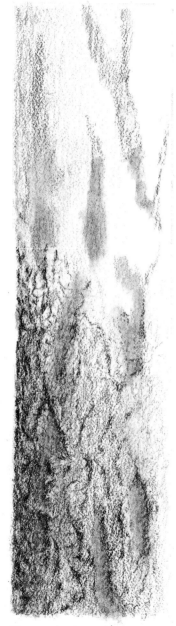

### Fir Bark

**1** Layer areas of Sienna Brown and Terra Cotta randomly. Layer French Grey 70% and 20%, as shown.

**2** Wash separately, with rubber cement thinner and a small brush, Sienna Brown, Terra Cotta, then French Grey 70% and 20%.

**3** Layer Sepia and French Grey 90%, building texture with small circular strokes.

**4** Layer very lightly over entire area, except Sepia/Terra Cotta areas, with Light Umber.

### Alder Bark

**1** Layer Jade Green, using horizontal strokes as shown. Wash/dab with rubber cement thinner and a small brush.

**2** Layer French Grey 90%, using horizontal strokes as shown. Lightly wash/dab with rubber cement thinner and a small brush.

**3** Lightly layer Apple Green randomly. Wash/dab with rubber cement thinner and a small brush.

**4** Layer Sepia and Dark Brown to areas described in Step 2.

**5** Layer/burnish French Grey 50% and Jade Green (left side).

**6** Lightly scrape, Dark Brown and Grey areas, using no. 16 X-Acto knife. Dab randomly with rubber cement thinner and a small brush.

**7** Lightly burnish randomly with White.

**Fir Palette**

Sienna Brown
Terra Cotta
French Grey 70%
French Grey 20%
Sepia
French Grey 90%
Light Umber

**Alder Palette**

Jade Green
Deco Aqua
French Grey 90%
Sepia
Dark Brown
French Grey 50%
Apple Green
White

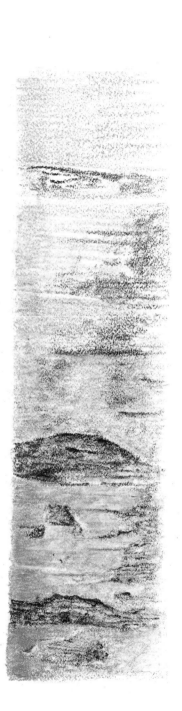

# Bark

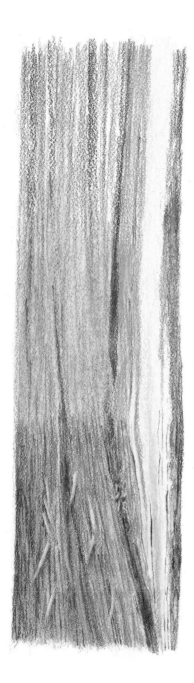

## Cypress Bark

1 Layer Cream and Goldenrod (right side only). Wash with rubber cement thinner and a small brush.

2 Layer Pumpkin Orange, Henna, Tuscan Red and Dark Purple using long vertical strokes as shown. Wash with rubber cement thinner and a small brush.

3 Layer using vertical strokes, Terra Cotta, Dark Umber, Purple Verithin and Dark Brown Verithin, as shown.

4 Scrape loose bark strands with a no. 16 X-Acto knife. Use a sharp blade and light strokes.

## Palm Bark

1 Layer Burnt Yellow Ochre. Wash with water and a medium brush. Avoid using too much water. Dry with hair dryer.

2 Layer Sand and Deco Orange. Wash with rubber cement thinner and a cotton swab.

3 Layer details with Light Umber and Dark Umber. Erase lighter values on edge of detail areas with sharpened imbibed eraser in electric eraser. Draw fine lines and sharpen details with Dark Brown Verithin.

---

### Cypress Palette

Cream
Goldenrod
Pumpkin Orange
Henna
Tuscan Red
Dark Purple
Terra Cotta
Dark Umber
Purple (Verithin)
Dark Brown
  (Verithin)

---

### Palm Palette

Burnt Yellow
  Ochre (Derwent
  Watercolour
  Pencil)
Sand
  (Spectracolor)
Deco Orange
Light Umber
Dark Umber
Dark Brown
  (Verithin)

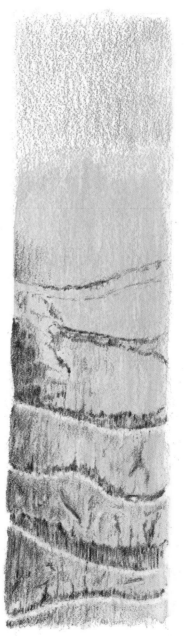

# Unfinished Wood

Try scraping your unfinished wood painting with a no. 16 X-Acto knife in a cross-grain direction to produce a realistic rough texture.

1 Layer Jasmine and Deco Yellow. Wash with rubber cement thinner and a cotton swab.

2 Layer wood grain as shown with Sienna Brown and Mineral Orange.

3 Wash wood grain with rubber cement thinner and a small brush.

4 Burnish wood grain with Cream and Sand.

5 Layer with Sand, using long strokes in grain direction.

**Color Palette**

Jasmine
Deco Yellow
Sienna Brown
Mineral Orange
Cream
Sand
    (Spectracolor)

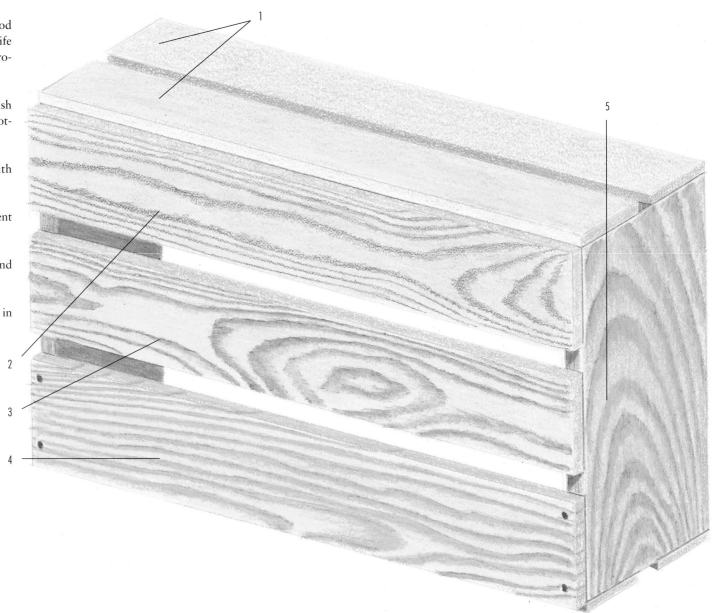

# Wood Finishes

## Oak Finish

**1** Layer Burnt Yellow Ochre. Wash with water and a medium brush.

**2** Layer Light Umber. Wash with rubber cement thinner and a cotton swab.

**3** Layer Sienna Brown and Dark Umber (grain only).

## Maple Finish

**1** Layer Burnt Yellow Ochre and Burnt Sienna. Wash with water and a medium brush.

**2** Layer Terra Cotta and Sienna Brown (grain only).

**3** Wash grain with rubber cement thinner and a small brush.

## Mahogany Finish

**1** Layer Copper Beech. Wash with water and a medium brush.

**2** Layer Tuscan Red. Wash with rubber cement thinner and a cotton swab.

**3** Layer Dark Umber (grain only).

## Walnut Finish

**1** Layer Light Umber. Wash with rubber cement thinner and a cotton swab.

**2** Layer Dark Umber (grain only). Wash with rubber cement thinner and a small brush.

**3** Layer Black randomly (grain only).

**Color Palette**

**OAK**
Burnt Yellow
    Ochre (Derwent
    Watercolour
    Pencil)
Light Umber
Sienna Brown
Dark Umber

**MAPLE**
Burnt Yellow
    Ochre (Derwent
    Watercolour
    Pencil)
Burnt Sienna
    (Derwent
    Watercolour
    Pencil)
Terra Cotta
Sienna Brown

**Color Palette**

**MAHOGANY**
Copper Beech
    (Derwent
    Watercolour Pencil)
Tuscan Red
Dark Umber

**WALNUT**
Light Umber
Dark Umber
Black

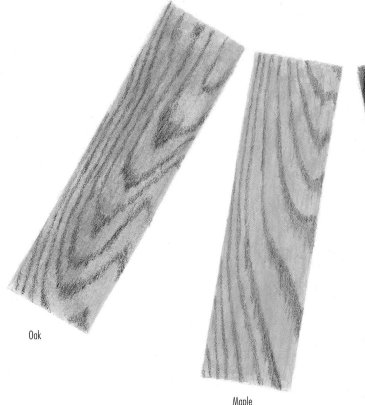

Oak

Maple

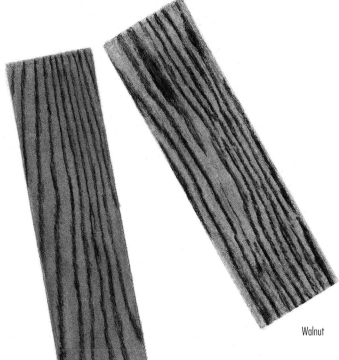

Mahogany

Walnut

# Weathered Wood

W eathered wood is a popular subject that can be easily and beautifully painted with colored pencil using a variety of techniques.

## White Wood

**1** Using vertical strokes, layer Cool Grey 20% to establish grain pattern. Wash with rubber cement thinner and a small brush.

**2** Randomly layer Cool Grey 70% as shown.

**3** Layer Cool Grey 50%. Relayer Cool Grey 20%.

## Red Wood

**1** Layer Brownish Beige. Wash with water and a medium brush.

**2** Layer Light Umber. Wash with rubber cement thinner and a cotton swab.

**3** Layer Crimson Red in grain pattern. Layer Crimson Red and Crimson Lake in concentrated red areas. Dab red with rubber cement thinner and a small brush.

**4** Relayer Crimson Red.

**5** Add details by burnishing Warm Grey 90% and Dark Umber. Add highlights by scraping with a no. 16 X-Acto knife.

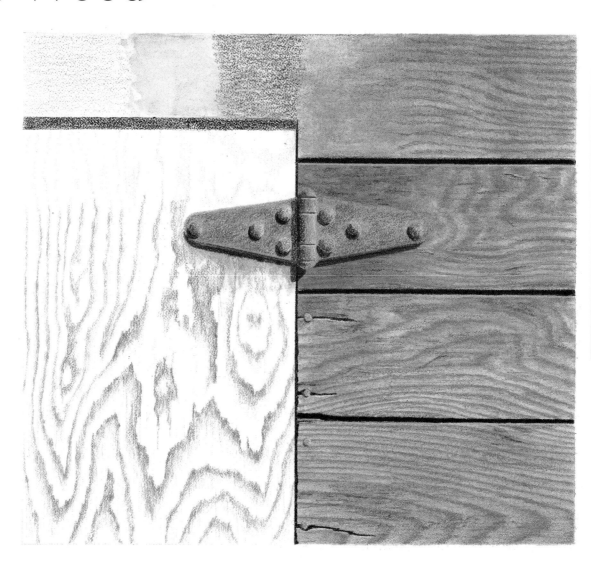

**Color Palette**

**RED WOOD**
Brownish Beige
(Caran d'Ache
Supracolor II
Soft Water
Soluble)
Light Umber
Crimson Red
Crimson Lake
(Spectracolor)
Warm Grey 90%
Dark Umber

**WHITE WOOD**
Cool Grey 70%
Cool Grey 50%
Cool Grey 20%

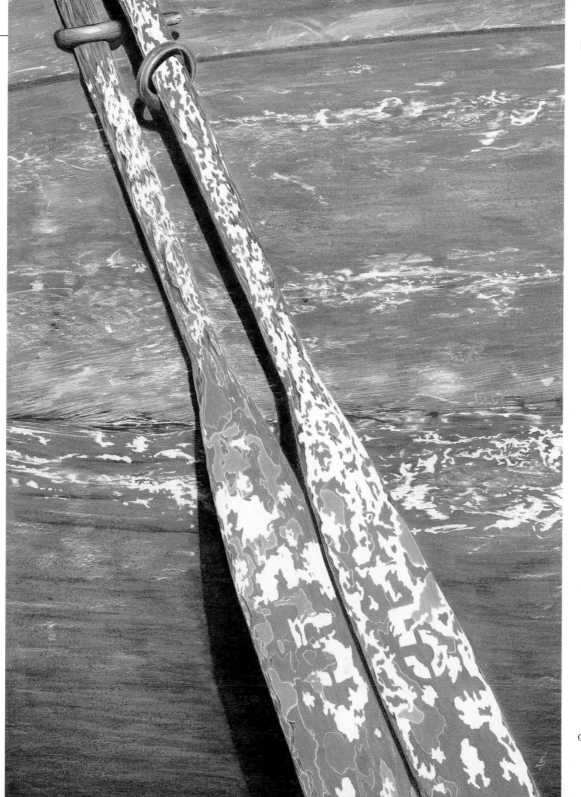

*Oars,* 32" x 20"

# Sand, Gravel, Soil

B y using water soluble pencils and/or solvents with wax/oil-based pencils, these textures can be rendered with relative ease and great enjoyment.

## Color Palette

**SAND**
Light Peach
French Grey 30%
Light Umber
French Grey 90%
Tuscan Red

**GRAVEL**
Cool Grey 10% through 90%
Warm Grey 10% through 90%
French Grey 10% through 90%
Slate Gray (Spectracolor)
Light Umber

**SOIL**
Vandyke Brown (Derwent Watercolour Pencil)
Dark Umber
Dark Brown
Sienna Brown

## Sand

1 Layer Light Peach and French Grey 30%.

2 Wash with rubber cement thinner and a cotton swab.

3 Layer Light Umber, Dark Umber, French Grey 90% and Tuscan Red. Randomly stipple same colors.

## Gravel

1 Randomly layer/burnish all colors as shown.

2 Dab with rubber cement thinner and a cotton swab, changing swabs frequently.

3 Spot erase with sharpened imbibed eraser strip in an electric eraser for white stones. Layer/burnish Warm or Cool Grey 90% to one side of the stones.

## Soil

1 Layer/wash Vandyke Brown with water and a medium brush.

2 Layer/burnish Dark Umber, Dark Brown and Sienna Brown.

3 Dab with rubber cement thinner and a cotton swab. Layer/burnish Dark Umber, Dark Brown and Sienna Brown.

# Rocks

Rocks can play an important role in a successful painting, either as part of a landscape or as the primary subject.

Rocks vary greatly in hue, therefore a specific color palette can't be given. Use grays, browns and any earth colors in the underpainting, then layer with a corresponding darker color. Add an occasional second color as shown on the rock at the right center of the group here.

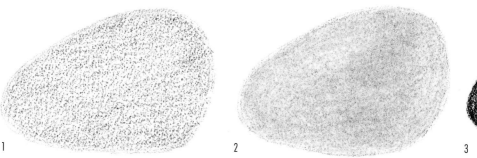

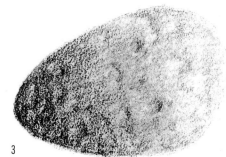

**1** Layer Warm Grey 30%.

**2** Wash with rubber cement thinner and a cotton swab.

**3** Layer details and texture with Warm Grey 90%, Warm Grey 50% and Warm Grey 20%.

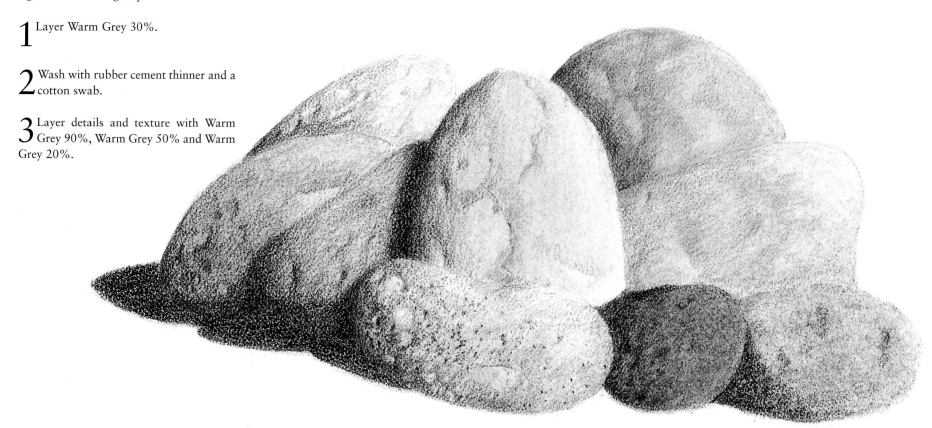

# Calm Water

**W**ater can be a challenge to depict in any medium, but if you study its texture and understand its appearance, the challenge can be less daunting and more enjoyable to paint.

1 Lightly layer Sky Blue randomly over entire area to be painted. Wash with water and a medium brush. An uneven effect is desirable.

2 Layer/burnish Slate Grey as shown.

3 Wash with rubber cement thinner and medium to small brushes.

4 Burnish Slate Gray.

5 Burnish Cool Grey 20% and Cool Grey 50% as shown.

**Color Palette**

Sky Blue (Derwent Watercolour Pencil)
Slate Gray (Spectracolor)
Cool Grey 20%
Cool Grey 50%

# Rough Water

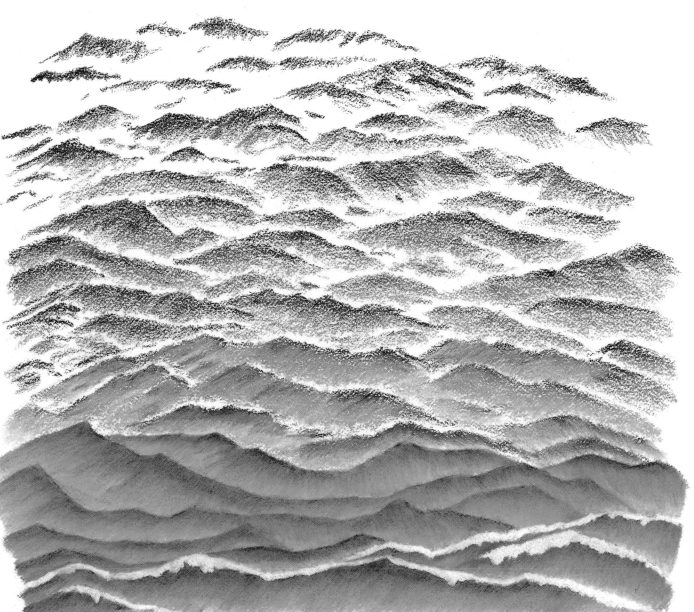

**1** Layer Cool Grey 90%, Dark Green, Peacock Green, Parrot Green and Light Aqua as shown.

**2** Layer/burnish over Cool Grey 90% with Peacock Green, remainder with Parrot Green and Light Aqua.

**3** Burnish all with Cool Grey 20% and Cool Grey 10%.

**4** Repeat Step 2 as required.

**5** Erase with sharpened imbibed eraser strip in an electric eraser to create whitecaps. Burnish with White. Create edges with corresponding color.

**6** Sharpen edges with Sea Green Verithin.

---

**Color Palette**

Cool Grey 90%
Dark Green
Peacock Green
Parrot Green
Light Aqua
Cool Grey 20%
Cool Grey 10%
White
Sea Green
  (Verithin)

---

# Rapid Water

The reference photo used for this illustration was taken with a camera using a slow shutter speed, creating a "milky," soft appearance to the rapidly moving water. When painting water in this way, it's important to remember that less is more—that is, use a minimum of pigment and a lot of bare paper.

1 Paint rocks (see page 77).

2 Lightly layer Cool Grey 50%, 20%, 10% and Cloud Blue. Leave the majority of the water free of color.

3 Wash with rubber cement thinner and a cotton swab, being careful not to disturb the rocks.

4 Carefully erase portions of gray area with sharpened imbibed eraser strip in an electric eraser. Repeat steps 2 through 4 as necessary.

**Color Palette**

**WATER**
Cool Grey 50%
Cool Grey 20%
Cool Grey 10%
Cloud Blue

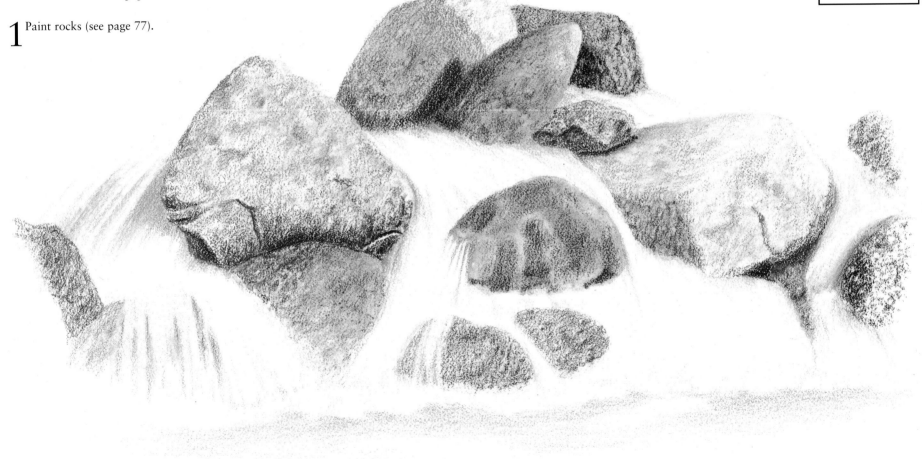

# Water Drops

1

2

3

4

Water drops can be rendered with amazing reality. The trick is to know the direction of the light source and to use the proper shading technique. The lightest spot, called the specular highlight (see illustration), should be round in shape (mimicking the sun) and not too large. Always leave this area completely free of pigment, allowing the paper surface to show through.

Although many water drops are spherical, try varying their shapes. Remember that water drops are little magnifying glasses. If a drop is on top of a pattern, a variegation for example, be sure to enlarge and shift the pattern immediately underneath it. Because the drop will be the color of the object it's painted on, no color palette is given here.

1 Leave area blank where drop is to be painted.

2 Draw the specular highlight with a Verithin Pencil.

3 Layer the darkest color in front of the specular highlight. Graduate colors from dark to light. Burnish with White, except in the darkest area. Relayer the same colors, except the darkest.

4 Add shadow using the darkest color, being careful not to extend the shadow around the sides of the drop. Burnish the shadow with the color of its surrounding area. Sharpen edges with a Verithin pencil.

# Shell

**1** Layer Tuscan Red, Indian Red and Raspberry at random. Leave some paper surface free of color as shown.

**2** Dab lightly with rubber cement thinner and a cotton swab

**3** Burnish White. Leave some areas of color and paper surface free of burnishing.

**4** Burnish and layer with Raspberry and White. Sharpen edges with Tuscan Red or White Verithin.

**Color Palette**

Tuscan Red
Indian Red (Lyra)
Raspberry
White
Tuscan Red
  (Verithin)
White (Verithin)

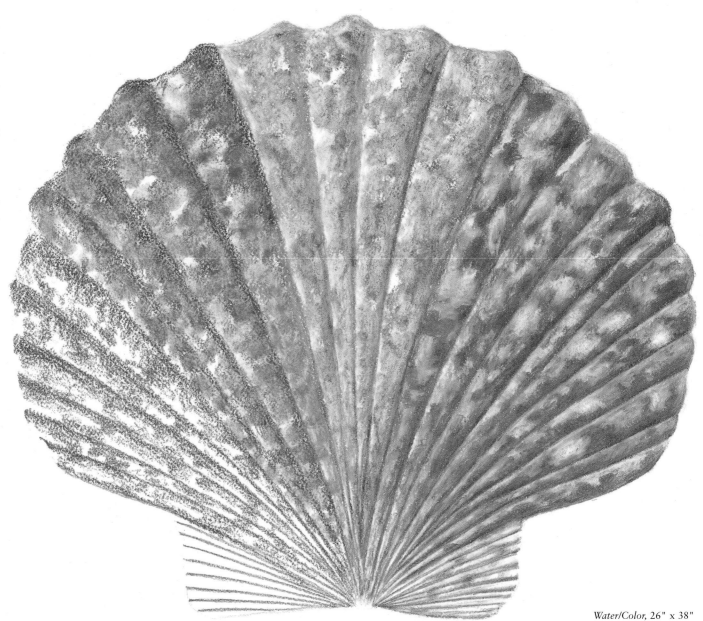

*Water/Color, 26" x 38"*

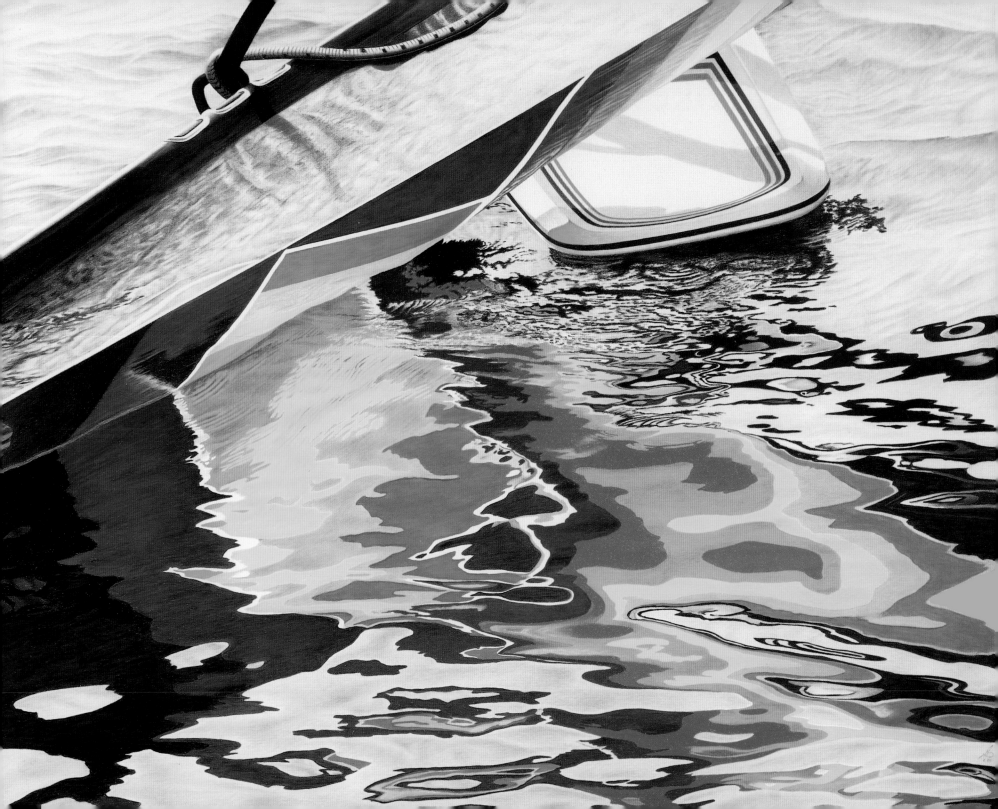

# Vertical Stroke Technique

Ann Kullberg developed her vertical line technique to accelerate the process of colored pencil painting and, when desired, to create a sense of movement in otherwise static areas, such as backgrounds. The technique is simple: color is layered with vertical strokes, the length determined by the amount of space to be colored. Smaller areas are layered with short strokes and larger areas with longer strokes. Colors are layered on top of each other within vertical strokes, using light pressure at first, then increasing it as color is added. Ann rarely burnishes her paintings, preferring to have the surface show through.

| Color Palette |
| --- |
| Peach |
| Orange |
| Goldenrod |
| Pumpkin Orange |
| Mineral Orange |
| Pale Vermilion |
| Sienna Brown |
| Burnt Ochre |

## Caucasian Skin

1 Layer Peach over the entire area.

2 Layer Orange for darker values.

3 Layer Goldenrod over entire area.

4 Layer Pumpkin Orange over Mineral Orange.

5 Layer Pale Vermilion, Sienna Brown and Burnt Ochre in darkest areas.

*Note:* Strokes are shown farther apart for example only.

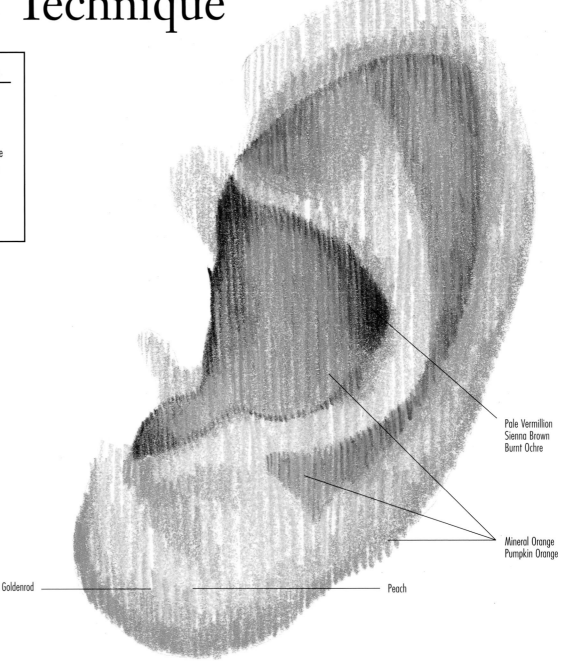

Pale Vermillion
Sienna Brown
Burnt Ochre

Mineral Orange
Pumpkin Orange

Goldenrod

Peach

# Vertical Stroke Technique

1

2

3

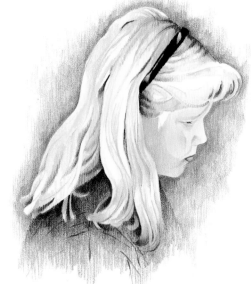

4

### Hair

**1** Outline with Goldenrod.

**2** Layer darker areas with Yellow Ochre and Goldenrod.

**3** Layer Deco Yellow, Burnt Ochre, Terracotta and Dark Brown.

**4** Layer Pumpkin Orange over Mineral Orange. Layer highlights with Canary Yellow, Warm Grey 10% and Warm Grey 20%. Layer darkest areas with Dark Umber.

---

**Color Palette**

Goldenrod
Yellow Ochre
Deco Yellow
Burnt Ochre
Terra Cotta
Dark Brown
Canary Yellow
Warm Grey 10%
Warm Grey 20%
Dark Umber

---

# Child

## Skin

**1** Layer Cream, Light Peach, Blush Pink, Deco Blue and Mineral Orange.

**2** Layer Yellow Ochre and Greyed Lavender.

**3** Layer Blush Pink, Deco Pink, Orange, Pink and Celadon Green.

## Eyes

**4** Layer Indigo Blue and Blue Slate.

**5** Layer Warm Grey 20%, Deco Blue, Black, Slate Grey (Spectracolor), Copenhagen Blue and Warm Grey 70%. Burnish with Cloud Blue.

## Hair

**6** Layer Jasmine and Dark Umber.

**7** Layer Light Umber, Burnt Ochre, Deco Yellow and Goldenrod.

**8** Layer Burnt Ochre, Light Umber, Celadon Green, Dark Umber and Yellow Ochre.

### Color Palette

**SKIN**
Cream
Light Peach
Deco Blue
Blush Pink
Mineral Orange
Yellow Ochre
Deco Pink
Greyed Lavender
Celadon Green

**EYE**
Indigo Blue
Blue Slate
Warm Grey 20%
Deco Blue
Black
Slate Grey
  (Spectracolor)
Copenhagen Blue
Warm Grey 70%
Cloud Blue

**HAIR**
Jasmine
Dark Umber
Light Umber
Burnt Ochre
Deco Yellow
Goldenrod
Celadon Green

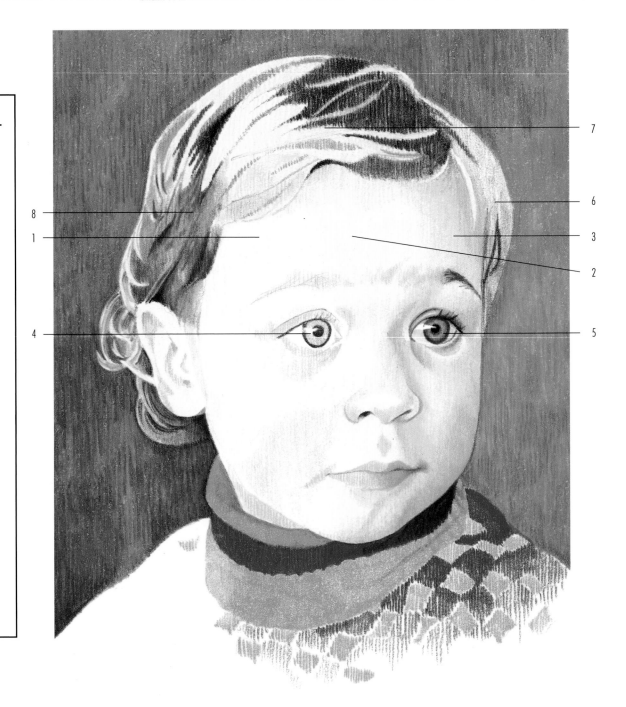

# Young Woman

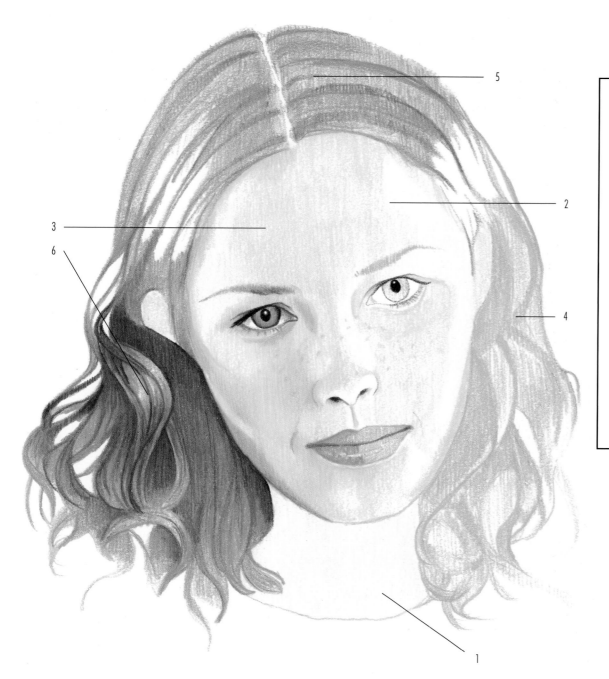

## Color Palette

**SKIN**
Light Peach
Cream
Deco Pink
Pink Rose
Rosy Beige
Jasmine
Blush Pink
Pumpkin Orange

**HAIR**
Peach
Yellow Ochre
Orange
Burnt Ochre
Sienna Brown
Tuscan Red
Pumpkin Orange
Crimson Red
Dark Umber

### Fair Skin

**1** Layer Light Peach and Cream.

**2** Layer Deco Pink, Light Peach, Pink Rose and Rosy Beige.

**3** Layer Jasmine, Blush Pink, Pumpkin Orange and Cream.

### Hair

**4** Layer Peach and Yellow Ochre.

**5** Layer Orange and Burnt Ochre.

**6** Layer Sienna Brown, Tuscan Red, Pumpkin Orange, Crimson Red and Dark Umber.

# Adult Man

## Skin

**1** Layer Light Peach and Jasmine.

**2** Layer Peach, Light Umber and Blush Pink.

**3** Layer Mineral Orange, Burnt Ochre, Pumpkin Orange, Yellow Ochre and Light Umber.

## Hair

**4** Layer Warm Grey 20% and Lavender.

**5** Layer Warm Grey 30%.

**6** Layer Light Umber, Dark Umber and Black.

## Facial Hair

**7** Impress line Cool Grey 50% (sideburn).

**8** Layer Light Umber and Dark Umber (mustache).

**9** Layer Tuscan Red, Black and Dark Umber. Burnish Warm Grey 10% (beard).

### Color Palette

**SKIN**
Light Peach
Jasmine
Peach
Light Umber
Blush Pink
Mineral Orange
Burnt Ochre
Pumpkin Orange
Yellow Ochre

**HAIR**
Warm Grey 20%
Lavender
Warm Grey 30%
Light Umber
Dark Umber
Black

**FACIAL HAIR**
Cool Grey 50%
Light Umber
Dark Umber
Tuscan Red
Black
Warm Grey 10%

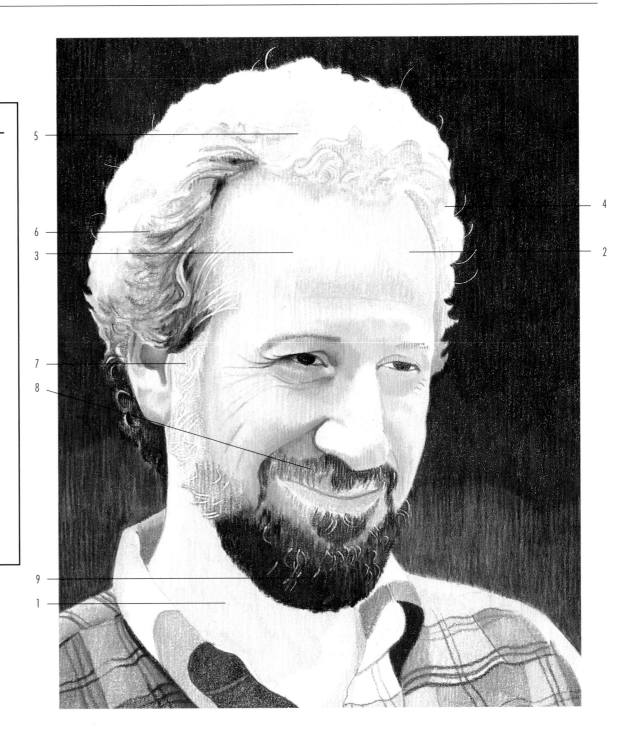

# Middle Aged Woman

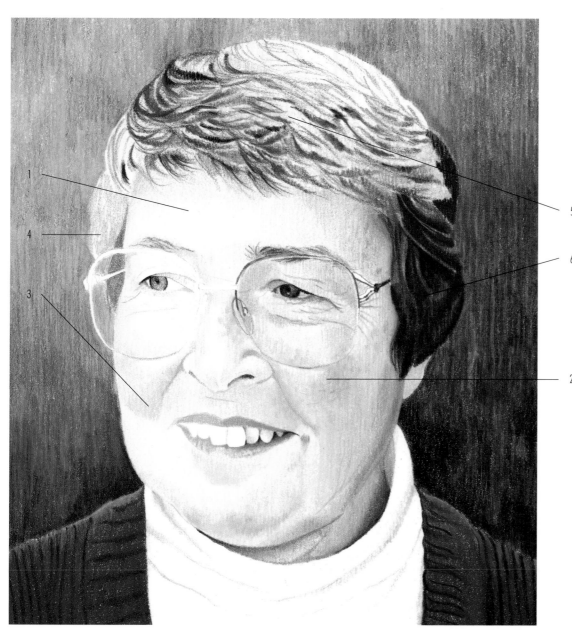

**Color Palette**

**SKIN**
Cream
Blush Pink
Light Peach
Cool Grey 20%
Yellow Ochre
Light Umber
Mineral Orange
Dark Brown
Jasmine
Goldenrod
Orange
Warm Grey 30%
Burnt Ochre
Terra Cotta
Dark Umber
Warm Grey 10%
Celadon Green

**HAIR**
Warm Grey 20%
Goldenrod
Burnt Ochre
Dark Brown
Light Umber
Deco Blue
Deco Yellow
Terra Cotta
Tuscan Red
Dark Umber
Black
Indigo Blue

## Skin

1 Layer Cream, Blush Pink, Light Peach, Cool Grey 20%, Yellow Ochre and Light Umber.

2 Layer Blush Pink, Mineral Orange, Dark Brown and Jasmine.

3 Layer Goldenrod, Orange, Light Umber, Mineral Orange, Blush Pink, Warm Grey 30%, Burnt Ochre, Terra Cotta, Dark Umber, Warm Grey 10% and Celadon Green.

## Hair

4 Layer Warm Grey 30%, Goldenrod and Burnt Ochre.

5 Layer Dark Brown, Light Umber, Deco Blue and Deco Yellow.

6 Layer Terra Cotta, Tuscan Red, Dark Umber, Black, Indigo Blue and Dark Brown.

# Senior

## Skin

**1** Layer Light Peach, Jasmine, Mineral Orange, Deco Pink, Yellow Ochre and Cool Grey 20%.

**2** Layer Burnt Ochre, Dark Umber, Carmine Red, Dark Brown, Blush Pink and Light Umber.

**3** Layer Warm Grey 20%, Goldenrod, Burnt Ochre, Terra Cotta, Carmine Red, Light Umber, Blush Pink, Mineral Orange and Pumpkin Orange.

## Hair

**4** Layer Cool Grey 10%, Cream and Warm Grey 20%.

**5** Layer Warm Grey 30%.

**6** Layer Jasmine, Peach and Burnt Ochre.

---

### Color Palette

**SKIN**

Light Peach
Jasmine
Mineral Orange
Deco Pink
Yellow Ochre
Cool Grey 20%
Burnt Ochre
Dark Umber
Carmine Red
Dark Brown
Blush Pink
Light Umber
Warm Grey 20%
Goldenrod
Terra Cotta
Pumpkin Orange

**HAIR**

Cool Grey 10%
Cream
Warm Grey 20%
Cool Grey 20%
Warm Grey 30%
Jasmine
Peach
Burnt Ochre

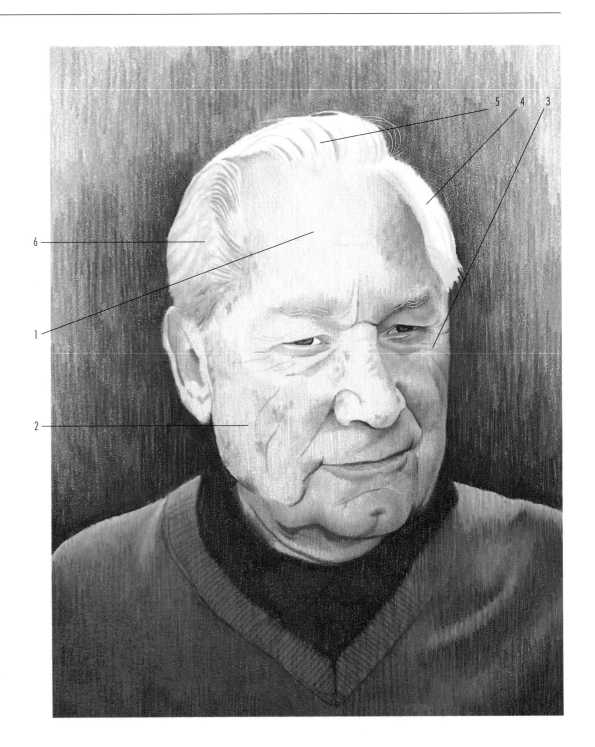

# Asian

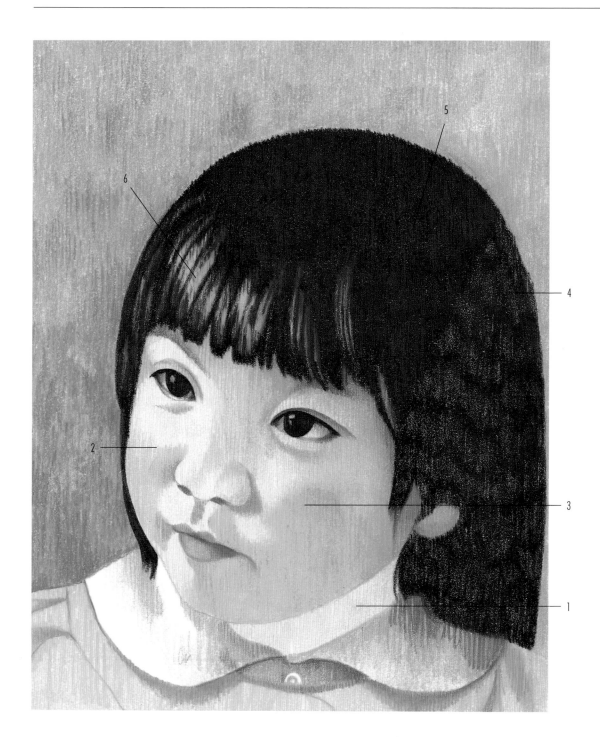

## Color Palette

**SKIN**
Jasmine
Light Peach
Yellow Ochre
Blush Pink
Burnt Ochre
Mineral Orange
Pink

**HAIR**
Tuscan Red
Black
Indigo Blue
Deco Blue
Warm Grey 30%
Mediterranean
 Blue
Dark Umber
White

## Skin

**1** Layer Jasmine and Light Peach.

**2** Layer Yellow Ochre, Blush Pink and Burnt Ochre.

**3** Layer Yellow Ochre, Blush Pink, Mineral Orange and Pink. Burnish Jasmine.

## Hair

**4** Layer Tuscan Red and Black.

**5** Layer Indigo Blue. Burnish Black.

**6** Layer Deco Blue, Warm Grey 30%, Mediterranean Blue and Dark Umber. Burnish White.

# African-American

## Skin

**1** Layer Goldenrod, Cream, Mineral Orange.

**2** Sienna Brown, Burnt Ochre, Blush Pink, Goldenrod.

**3** Burnt Ochre, Light Umber, Pink and Pale Vermilion.

## Hair

**4** Layer Black, Dahlia Purple and Cloud Blue.

**5** Layer Peach and Warm Grey 50%.

**6** Layer Black and Sienna Brown.

### Color Palette

**SKIN**
Goldenrod
Cream
Mineral Orange
Sienna Brown
Burnt Ochre
Blush Pink
Light Umber
Pink
Pale Vermilion

**HAIR**
Black
Dahlia Purple
Cloud Blue
Peach
Warm Grey 50%
Sienna Brown

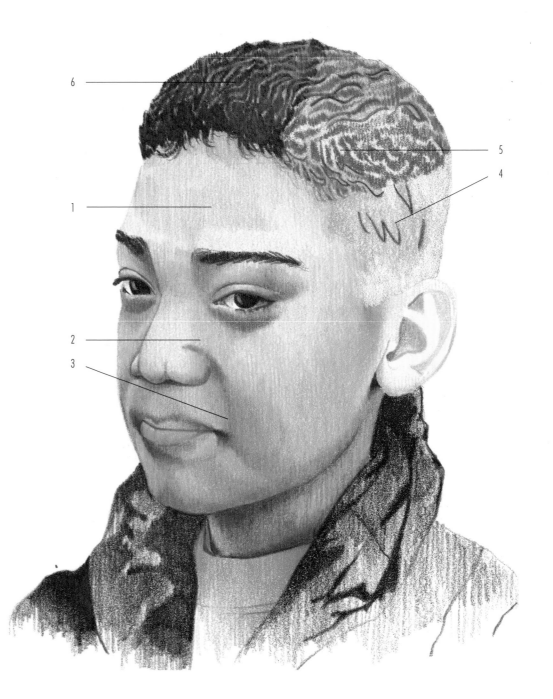

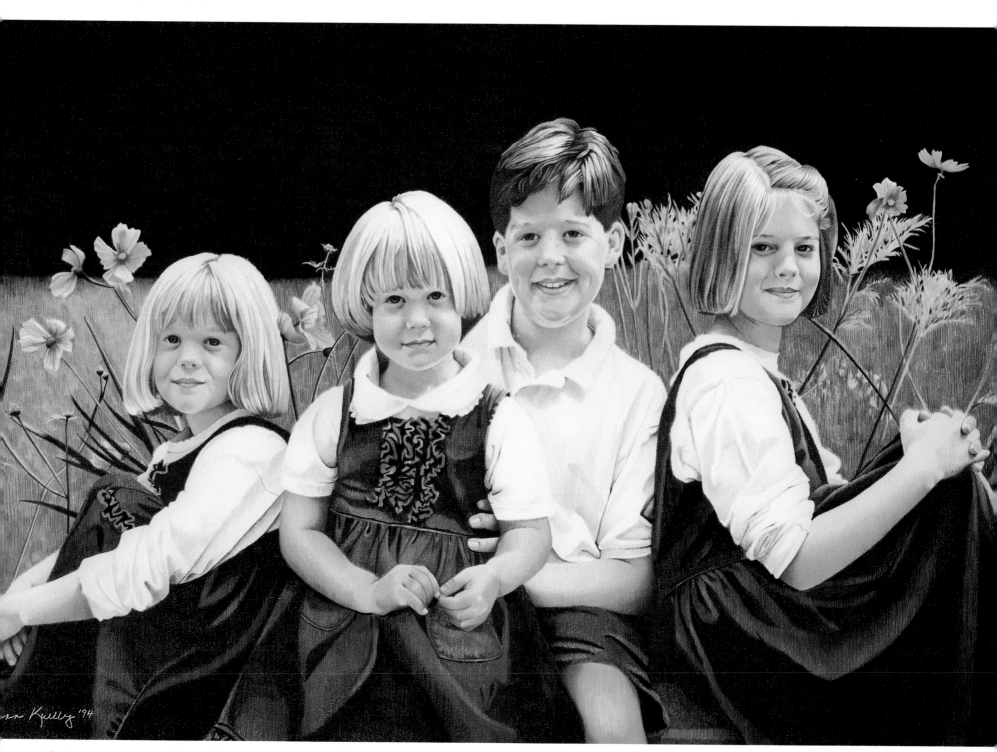

*The Mannix Family,* by Ann Kullberg, 20" x 26"

# Short Fur

Carolyn Rochelle's technique involves creating tonal gradations with strokes that follow the direction of an animal's coat, skin, etc., using medium pencil pressure. She usually layers from light to dark, often in a manner that allows underlying hues to show through. Carolyn sometimes burnishes to create reflections and smooth areas but usually limits this technique in favor of layering.

1 Layer Cream, Burnt Ochre and Warm Grey 70%. Use strokes following hair pattern.

2 Layer Burnt Umber (dark values).

3 Burnish highlight areas with Cream. Layer/burnish details with Black Medium.

---

**Color Palette**

Cream
Burnt Ochre
Warm Grey 70%
Burnt Umber
Black Medium
(Lyra Polycolor)

---

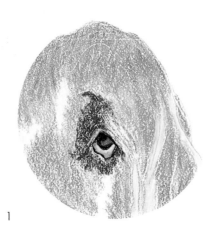

1

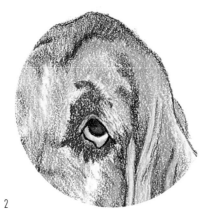

2

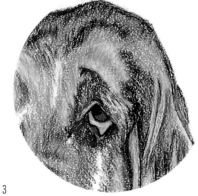

3

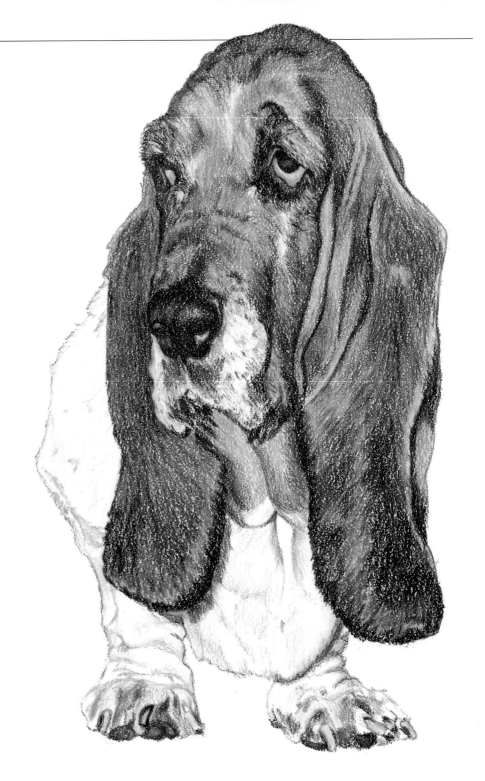

# Long Fur

**1** Layer entire area with White. Layer Warm Grey 20%. Burnish White.

**2** Layer Warm Grey 10%. Burnish White. Layer Warm Grey 30%. Burnish White.

**3** Lightly layer Rosy Beige and French Grey 70%.

---

**Color Palette**

White
Warm Grey 20%
Warm Grey 10%
Warm Grey 30%
Rosy Beige
French Grey 70%

---

1

2

3

# Shiny Fur

**1** Layer Black Grape and Jasmine.

**2** Layer/burnish French Grey 10%. Layer Goldenrod.

**3** Layer Sienna Brown, Burnt Ochre and Indigo Blue.

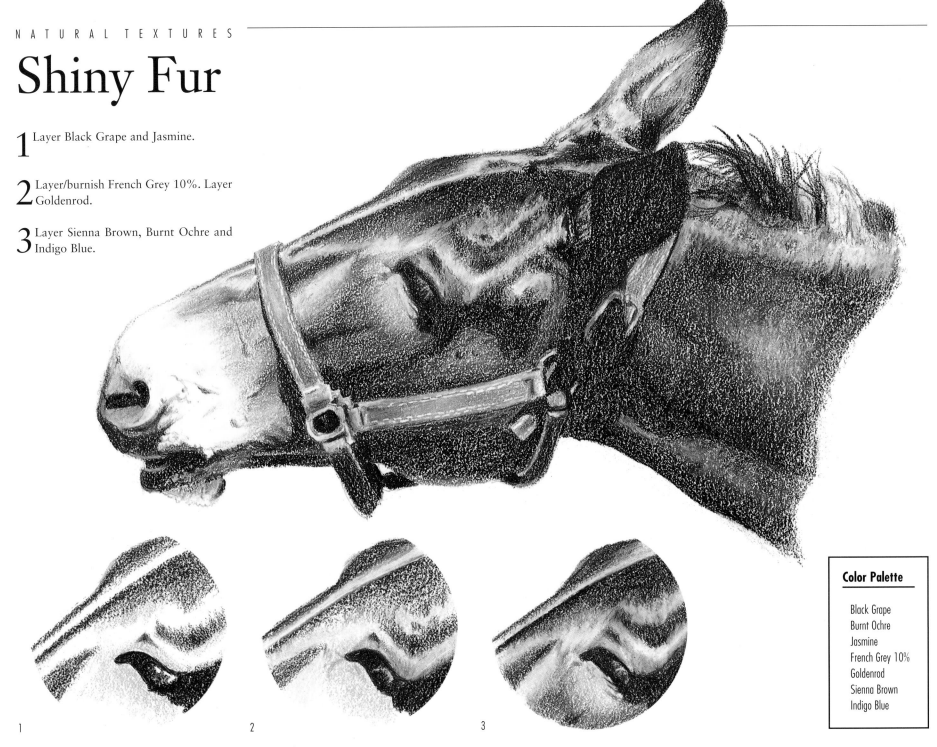

1

2

3

**Color Palette**

Black Grape
Burnt Ochre
Jasmine
French Grey 10%
Goldenrod
Sienna Brown
Indigo Blue

# Thick Fur

**1** Layer Cream (light fur). Layer Goldenrod (legs and muzzle).

**2** Layer Sienna Brown over Cream as shown. Layer Dark Brown over Dark Umber areas. Burnish with Cream over Sienna Brown/Cream areas. Burnish Dark Umber to redefine the darkest recesses in the fur.

**Color Palette**

Cream
Goldenrod
Dark Umber
Sienna Brown
Dark Brown

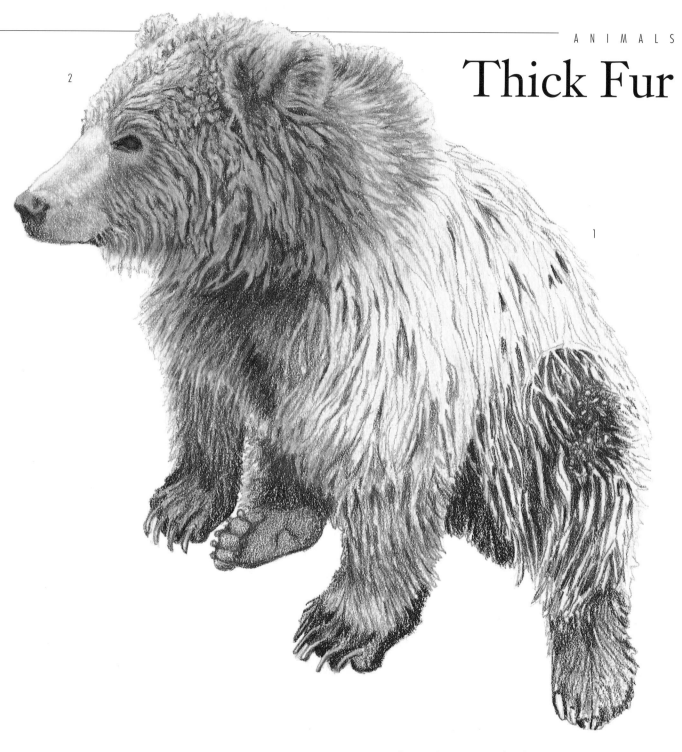

# Rough Hide

**1** Lightly layer Warm Grey 10%. Draw Black lines to define folds. Layer French Grey 50% using circular strokes.

**2** Lightly layer Rosy Beige using circular strokes over Warm Grey area. Layer Light Umber using circular strokes over French Grey 50% area. Layer French Grey 70% using circular strokes over Black hide folds.

**3** Layer Warm Grey 70%. Layer Sepia over Light Umber strokes.

## Color Palette

Warm Grey 10%
Black
French Grey 50%
Rosy Beige
Light Umber
French Grey 70%
Warm Grey 70%
Sepia

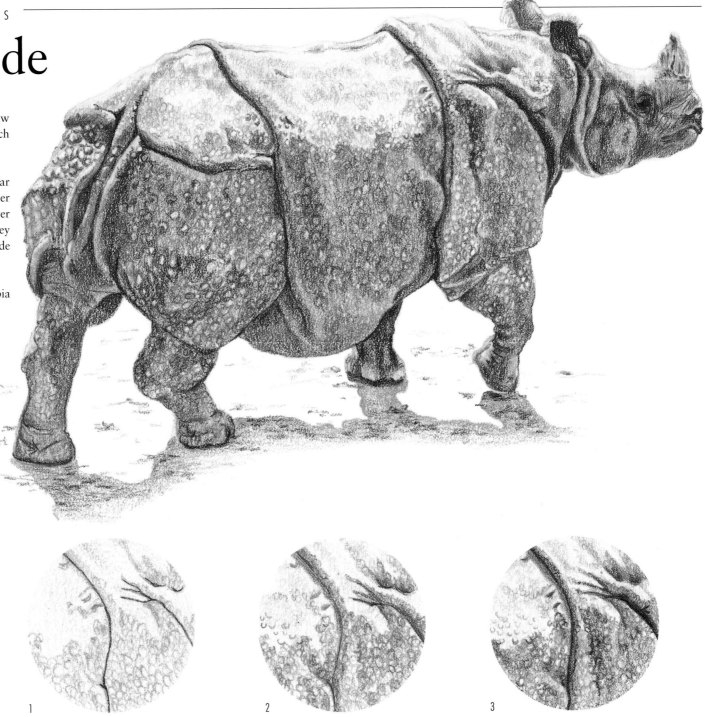

1

2

3

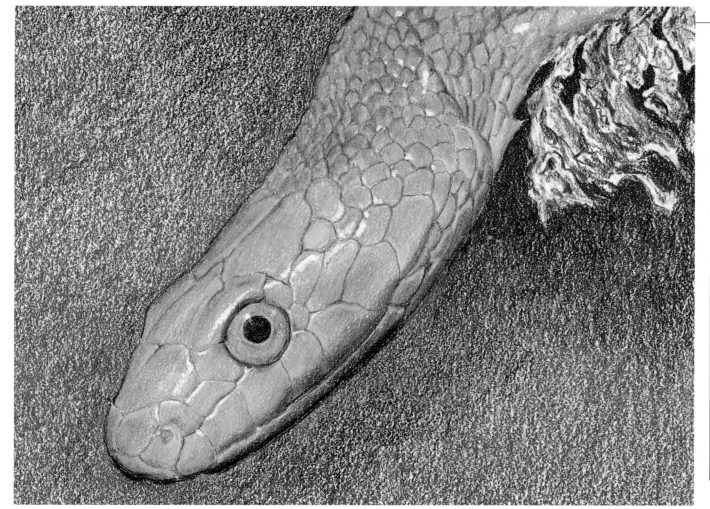

# Scales

**1** Draw scale divisions with Sienna Brown Verithin. Layer Spanish Orange, Pumpkin Orange and Light Umber.

**2** Layer Dark Purple. Burnish with White (Dark Purple area only).

**3** Layer Sand and Burnt Ochre.

| Color Palette |
| --- |
| Sienna Brown (Verithin) |
| Spanish Orange |
| Pumpkin |
| Light Umber |
| Dark Purple |
| White |
| Jasmine |
| Burnt Ochre |

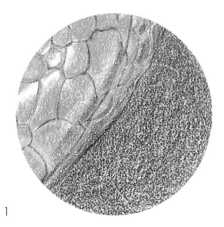

1

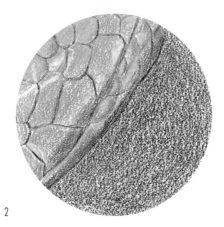

2

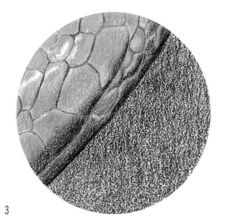

3

# Feathers

1 Layer Yellow Chartreuse on wing feathers. Layer Green Bice in darker areas. Layer Cream in adjacent chest area. Layer wing edge with Mediterranean Blue.

2 Layer/burnish Olive Green in shadow area and to define individual feathers. Layer Limepeel on small feathers. Layer Canary Yellow on lower chest feathers. Burnish with White, blending blue feathers and highlight areas.

3 Layer Raw Umber to define chest feathers. Layer/burnish Indigo Blue to darken shadow areas. Layer red chest area with Poppy Red and burnish with Cream. See main painting.

4 Layer head feathers with French Grey 50%. Layer Burnt Ochre and Indigo Blue to define feathers.

1

3

2

**Color Palette**

Yellow Chartreuse
Green Bice
Cream
Mediterranean Blue
Olive Green
Limepeel
Canary Yellow
White
Raw Umber
Indigo Blue
Poppy Red
French Grey 50%
Burnt Ochre
French Grey 50%
Indigo Blue
Tuscan Red
White

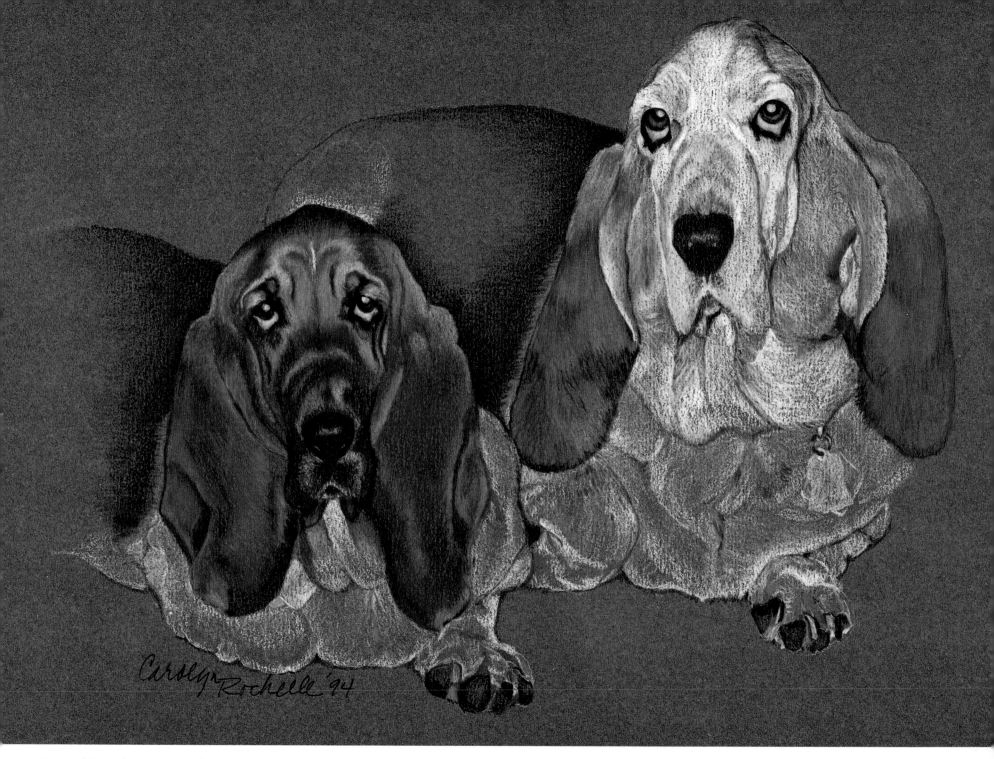

*Grace and Gomer*, by Carolyn Rochelle, 8½" x 11"

# Man~Made Textures

∞

By learning how to paint the examples in this section, you will be able to "spin off" other textures by using a different color palette, altering the technique or both. For example, chrome could be painted as gold, copper, or brass merely by using different colors.  ∞  The texture of an object may be identical to a totally unrelated object as well. For instance, the texture of porcelain is completed the same way as painted, polished metal.  ∞  Since many man-made objects are artificial, the use of straight edges, French curves, ship curves, templates, etc., can be used to lay out objects and tighten edges.

*Rusty Car, 25" x 34"*

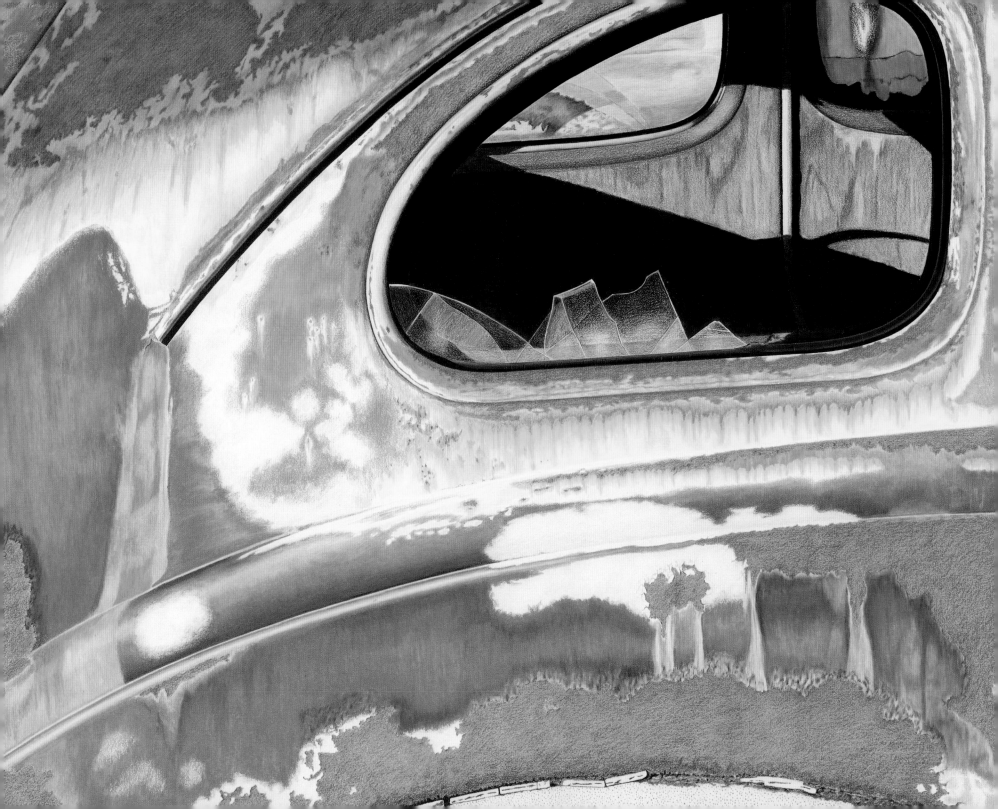

# Glass

The secret of painting glass successfully is to be aware of its character. Not only is glass reflective, but transparent, as well. This causes its reflectivity to be somewhat subdued because light from surrounding objects passes through the transparent glass. At the same time, objects behind the glass object are often distorted. By carefully studying and understanding the subject, you will paint glass like an expert.

## Blue Bottle

**1** Layer Cool Grey 90%, Indigo Blue, Violet Blue, Copenhagen Blue and True Blue. Leave highlight areas free of color.

**2** Burnish White.

**3** Layer/burnish Cool Grey 90% and Indigo Blue. Burnish Violet Blue and White. Repeat as required. For cap, burnish Indigo Blue Verithin and White, leaving highlights free of color. Sharpen edges with Indigo Blue or Azure Blue Verithin.

## Brown Bottle

**1** Layer Dark Umber, Dark Brown, Burnt Ochre, Sienna Brown and Terra Cotta. Leave highlight areas free of color.

**2** Burnish Goldenrod.

| Blue Bottle Color Palette | Brown Bottle Color Palette | Green Bottle Color Palette |
|---|---|---|
| Cool Grey 90% | Dark Umber | Warm Grey 90% |
| Indigo Blue | Dark Brown | Indigo Blue |
| Violet Blue | Burnt Ochre (Lyra) | Dark Green |
| Copenhagen Blue | Sienna Brown | Grass Green |
| True Blue | Terra Cotta | Olive Green |
| White | Goldenrod | Limepeel |
| Indigo Blue (Verithin) | French Grey 10% | Warm Grey 20% |
| Azure Blue (Verithin) | White | White |
| | Dark Brown (Verithin) | Indigo Blue (Verithin) |
| | | Grass Green (Verithin) |

**3** Layer Sienna Brown and Terra Cotta. Burnish Burnt Ochre, Goldenrod, French Grey 10% (secondary highlight area only) and White (around edge of highlight area only).

## Green Bottle

**1** Layer Warm Grey 90%, Indigo Blue, Dark Green, Limepeel, Olive Green and Warm Grey 20%. Leave highlight areas free of color

**2** Burnish White.

**3** Layer/burnish Indigo Blue, Cool Grey 90% and Grass Green. Burnish Limepeel and White. Repeat as required. Sharpen edges with Grass Green Verithin and Indigo Blue Verithin.

1

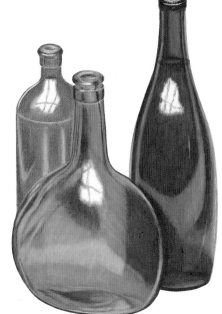

2

3

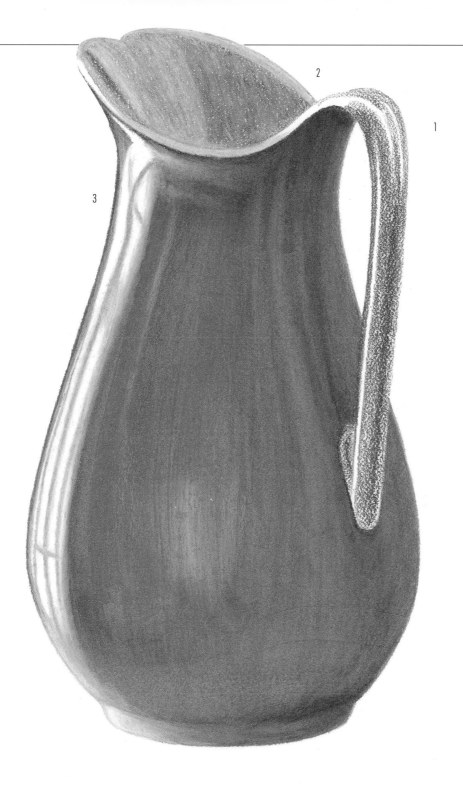

# Porcelain

**Color Palette**

Tuscan Red
Henna
Raspberry
Magenta
White
Magenta
(Verithin)

Painting Ceramic or Porcelain surfaces is similar to painting glass, except that these surfaces are opaque.

1 Layer Tuscan Red, Henna (darkest hues only), Raspberry and Magenta. Leave highlight areas free of color.

2 Burnish with White.

3 Layer Raspberry (darkest hues only). Burnish Magenta. Burnish White (secondary highlights only). Repeat Steps 2 and 3 if necessary.

# Shiny Metal

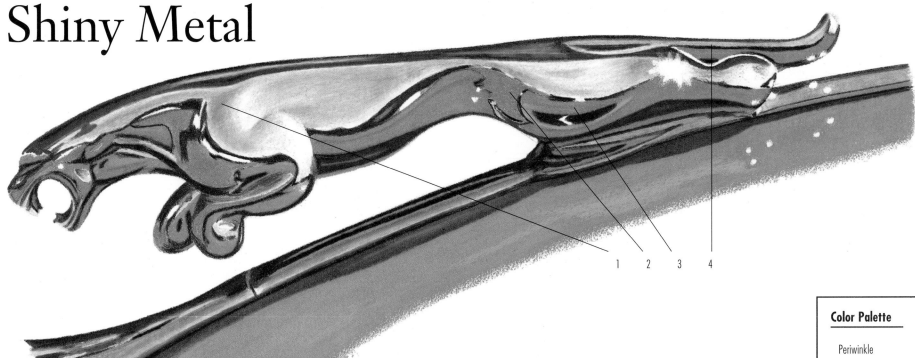

**Color Palette**

Periwinkle
Cloud Blue
White
Olive Green
Limepeel
Apple Green
Light Green
  (Verithin)
Crimson Red
Poppy Red
Pale Vermilion
  (Verithin)
Carmine Red
  (Verithin)
Black
Indigo Blue
Black (Verithin)
Indigo Blue
  (Verithin)

Painting chrome or reflective metal surfaces with colored pencil is a "natural" for the medium. A good reference photo will reveal the necessary detail to create a rewarding colored pencil painting. Leave out small, unnecessary details to simplify your painting.

1 Layer, in gradations, as shown, Periwinkle and Cloud Blue. Burnish White. Layer/burnish Periwinkle and Cloud Blue. For darker areas, omit White burnish.

2 Layer Olive Green and Limepeel. Burnish Apple Green. Sharpen edges with Light Green Verithin.

3 Layer Crimson Red and Poppy Red. Burnish lighter areas with White. Burnish all with Poppy Red. Sharpen edges with Pale Vermilion (Verithin) or Carmine Red Verithin.

4 Layer Indigo Blue and Black. Burnish with Indigo Blue. For darker areas, burnish with Black. Sharpen edges with Indigo Blue or Black Verithin.

**Note**

- Each area of color is painted to completion, starting with the lightest color to prevent contamination by dragging adjacent stronger colors into lighter areas.
- Small details should be painted with Verithins.
- Leave highlights free of color.

# Rust

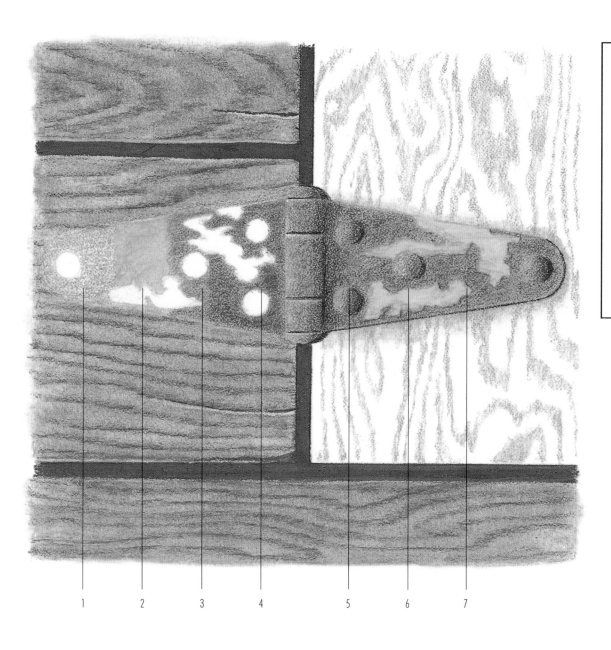

### Color Palette

Pumpkin Orange
Dark Umber
Tuscan Red
Terra Cotta
Light Umber
Mineral Orange
French Grey 90%
Terra Cotta
  (Verithin)
Black (Verithin)

**PEELING PAINT**
Goldenrod
Yellow Orange

1 Layer Orange Pumpkin or leave rivets and peeling paint free of pigment.

2 Wash with rubber cement thinner and a small brush.

3 Layer Dark Umber, Tuscan Red, Terra Cotta, Light Umber and Mineral Orange.

4 Dab with rubber cement thinner and a small brush. Repeat step 3 as required.

5 Complete rivets using steps 1-4.

6 Peeling paint—layer Goldenrod and burnish with Sunburst Yellow.

7 Layer/burnish shadow areas with French Grey 90% and Black Verithin. Sharpen edges with Terra Cotta Verithin and Black Verithin.

# Paper Bag

The primary consideration in painting paper is that the "wrinkles" have sharp, well-defined edges, as opposed to cloth, which has smooth, soft folds.

1 Layer Sand.

2 Wash with rubber cement thinner and a cotton swab.

3 Layer Light Ochre.

4 Wash with rubber cement thinner and a cotton swab.

5 Layer Light Ochre.

6 Wash with rubber cement thinner and a cotton swab. Develop creases by erasing and layering/burnishing Light Umber. Wash with rubber cement thinner and a small brush. Repeat as necessary. Add French Grey 90% to darkest values only.

**Color Palette**

Sand
  (Spectracolor)
Light Ochre
French Grey 90%

# Rubber Balloon

The balloon's surface is not as reflective as glass or porcelain. To achieve this effect, burnish the highlight area with white, instead of allowing the paper surface to show through.

1 Layer Tuscan Red (darkest values only), Crimson Lake, Crimson Red, Scarlet Lake and Poppy Red. Leave highlight area free of color.

2 Burnish with White.

3 Layer/burnish Scarlet Lake (darkest areas only). Burnish Poppy Red, and White. Drag color into highlight area with White. Sharpen edges with Tuscan Red Verithin and Carmine Red Verithin.

**Color Palette**

Tuscan Red
Crimson Lake
    (Spectracolor)
Crimson Red
Scarlet Lake
Poppy Red
White
Tuscan Red
    (Verithin)
Carmine Red
    (Verithin)

# Shiny Cloth

Allowing the white of the paper surface to show through for the highlights and burnishing adjacent to them with white only will help you realistically depict the texture of any shiny cloth.

1 Layer, in gradations, Process Red (darkest values only), Hot Pink, Pink and Deco Pink. Leave paper free of color for highlights.

2 Burnish with White.

3 Layer Hot Pink (darkest values only) and Pink. Burnish with Deco Pink and White (secondary highlight areas). Sharpen edges with Pink Verithin.

**Color Palette**

Process Red
Hot Pink
Pink
Deco Pink
White
Pink (Verithin)

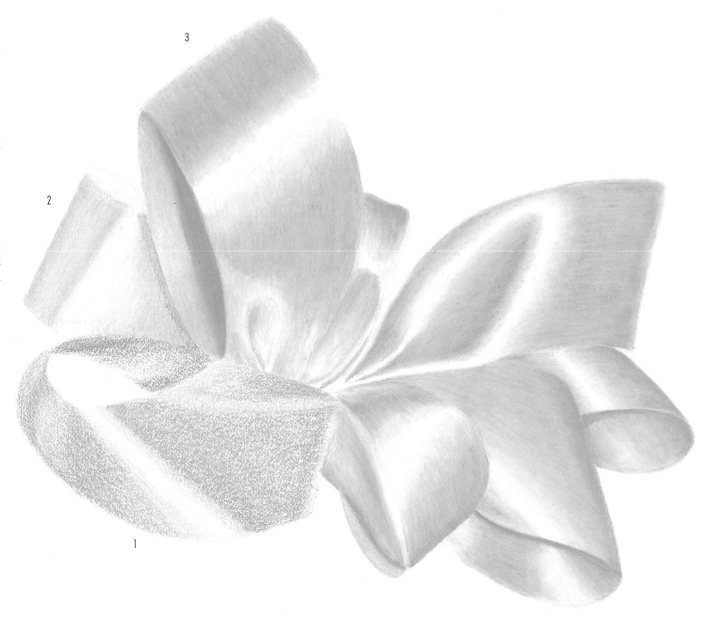

# Dull Cloth

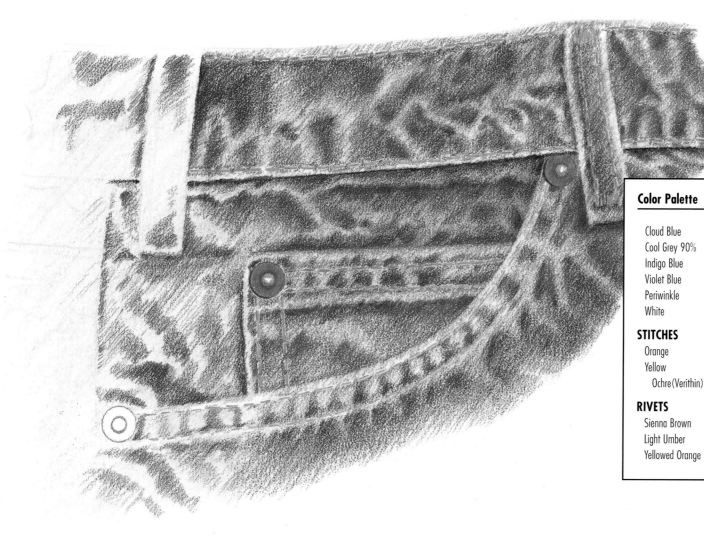

Angular hatch strokes help make cloth texture look more realistic. A circle template was used to lay out the rivets.

1 Using angular strokes, layer Cloud Blue.

2 Using angular strokes, wash with rubber cement thinner and a cotton swab.

3 Using angular strokes, layer Cool Grey 90% (darkest value bottom waist seam only), Indigo Blue, Violet Blue, Periwinkle and Cloud Blue. Leave rivet area free of color.

4 With a sharpened imbibed eraser strip in an electric eraser, carefully erase a thin line for stitching.

5 Burnish Orange Verithin and Yellow Ochre Verithin in dash pattern. Burnish with White. Re-layer around stitches with blue.

6 Layer rivets as shown with Sienna Brown and Light Umber. Burnish Yellowed Orange.

**Color Palette**

Cloud Blue
Cool Grey 90%
Indigo Blue
Violet Blue
Periwinkle
White

**STITCHES**
Orange
Yellow
    Ochre (Verithin)

**RIVETS**
Sienna Brown
Light Umber
Yellowed Orange

# Bricks and Mortar

**B**ricks are not all exactly alike, so vary the amount of each color from brick to brick.

## Mortar

**1** Layer Cool Grey 10% using circular strokes.

**2** Layer Cool Grey 50% using circular strokes and a flattened point.

**3** Stipple Cool Grey 90% randomly.

## Bricks

**1** Layer Terra Cotta, Indian Red and Pumpkin Orange using vertical strokes.

**2** Wash with rubber cement thinner and a cotton swab using vertical strokes. A small brush may be substituted around edges.

**3** Layer Tuscan Red using vertical strokes. Randomly tap lightly with kneaded eraser. Lightly relayer Pumpkin Orange using vertical strokes. Highlight with Dark Umber at bottom left and White at top right.

**Color Palette**

**BRICKS**
Terra Cotta
Indian Red (Lyra)
Pumpkin Orange
Tuscan Red
Terra Cotta
   (Verithin)
Dark Umber
White

**MORTAR**
Cool Grey 10%
Cool Grey 50%
Cool Grey 90%

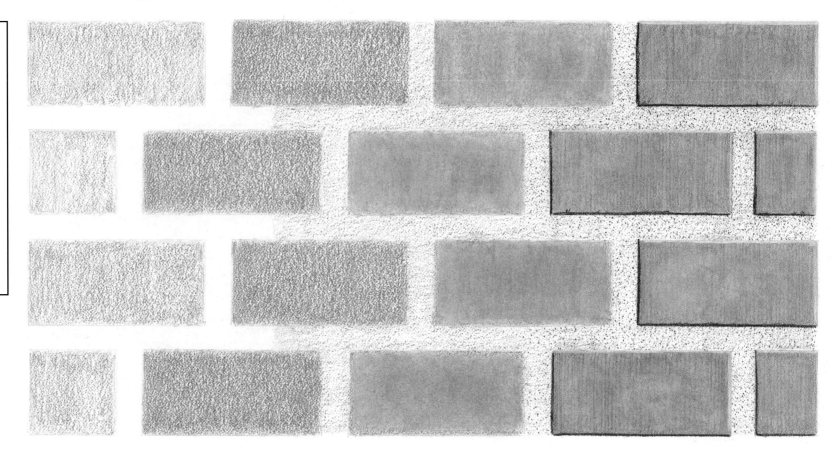

# Wicker

1 Layer entire area with Sand and Light Peach.

2 Wash with rubber cement thinner and a cotton swab.

3 Layer/burnish Goldenrod in darkest areas.

4 Burnish with Cream (lightest areas). Burnish with Jasmine (secondary shadow areas).

**Color Palette**

Sand
  (Spectracolor)
Light Peach
Goldenrod
Jasmine
Cream

Goldenrod

Jasmine

Creme

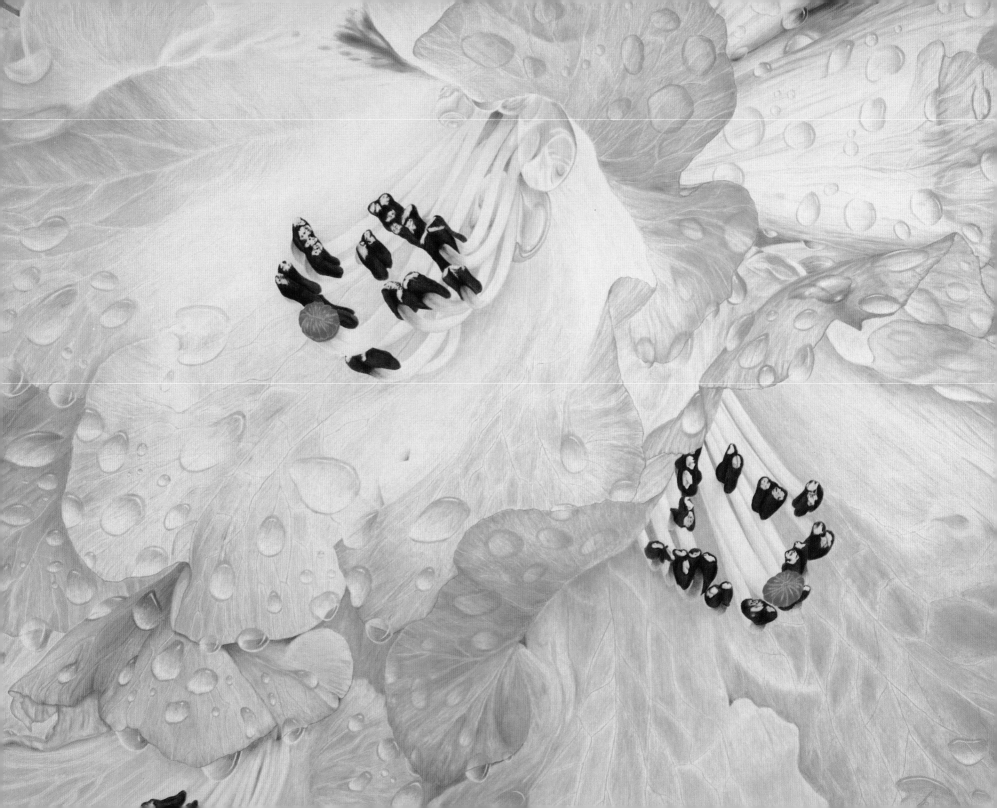

**Ann Kullberg**

After earning her Bachelor's Degree from Pacific Lutheran University in Tacoma, Washington, Ann taught junior high school English, married, and began raising two children. In her spare time she found great joy in painting with watercolor and pastel. In 1987, she discovered colored pencil. Her life was changed forever. She is currently one of the leading portrait artists working in colored pencil. Her work appears in *Creative Colored Pencil* by Vera Curnow (Rockport Books), and *The Best of Colored Pencil, Volume 2* (Rockport Books). She is represented by several galleries and conducts workshops throughout the Northwest. Ann has a nationally distributed greeting card line, and has received awards and recognition from, among others, *The Artist's Magazine* and the Frye Art Museum in Seattle, Washington. Ann is a member of the Colored Pencil Society of America.

**Carolyn Rochelle**

Carolyn and her husband live in a rural community near Tacoma, Washington. The beauty of her surroundings, as well as her love for animals and art, has made Carolyn a "natural" as an artist specializing in pet portraiture, wildlife and Western landscapes. Carolyn enjoyed working with pen and ink as a youngster, then later worked with watercolor and pastel for a number of years. In 1980, colored pencil became her primary art medium.

A degree in Art Education from the University of Puget Sound launched Carolyn's career. She first taught manual arts skills to blind veterans, then operated a nursery with her husband, doing artwork on the side. Carolyn has recently decided to devote full time to her artwork, which has paid off in commissions, awards and regional gallery representation. Her animal portraiture has appeared in *The Encyclopedia of Colored Pencil Techniques,* by Judith Martin (Quarto), and *The Best of Colored Pencil, Volume 2* (Rockport Books). Carolyn is President of the Washington District Chapter of the Colored Pencil Society of America.

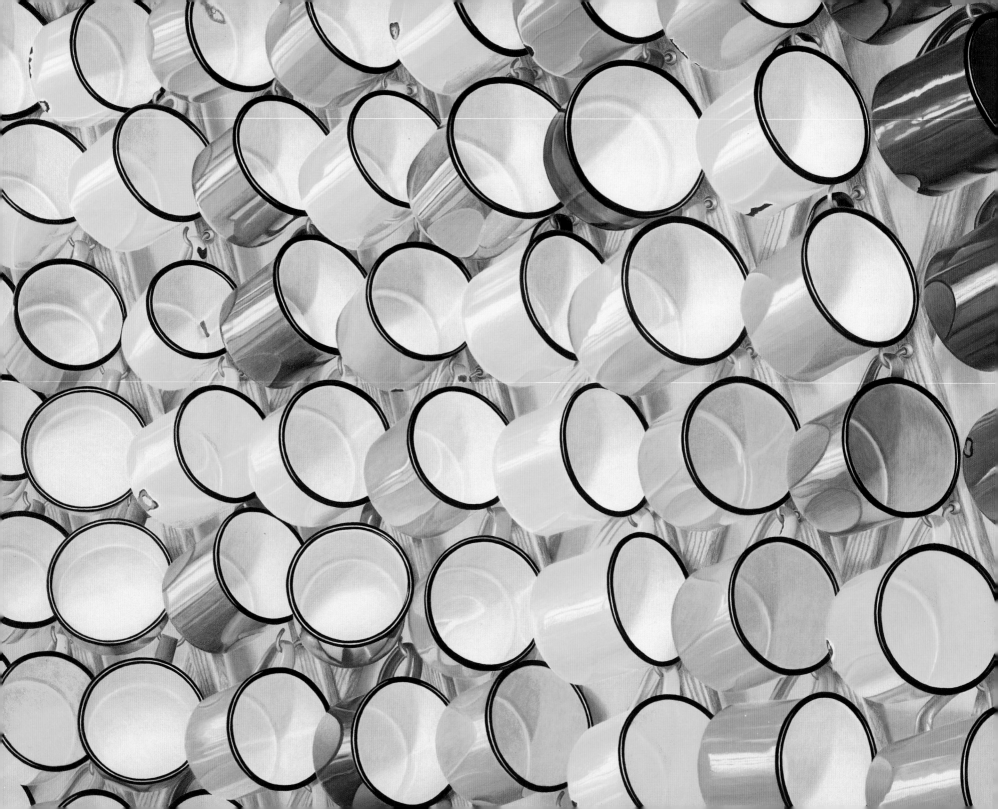

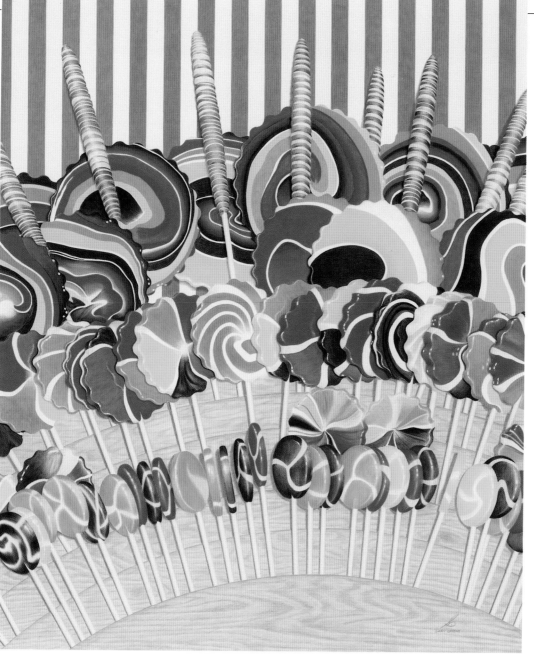

**Colored Pencil Society of America**

For further information about the Colored Pencil
Society of America, contact
Kay Dewar
Membership Director
3056 39th Avenue SW
Seattle, WA 98116

*I'm gonna get you, Suka,* 29" x 24"

*Cups,* 21" x 31"

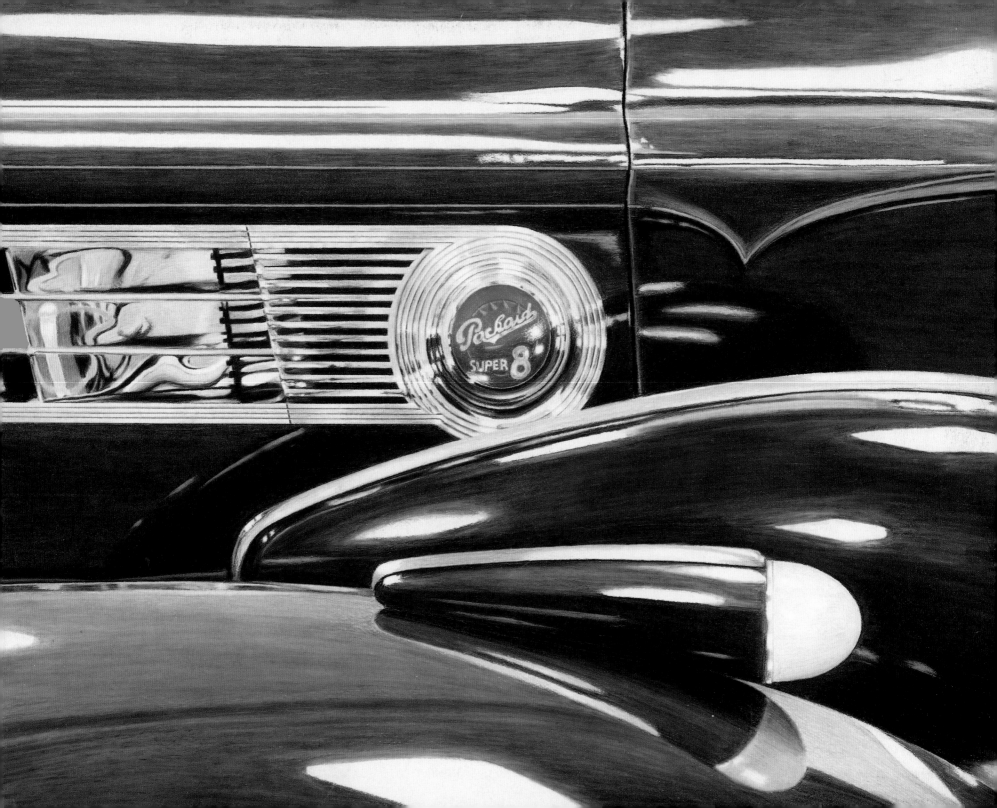

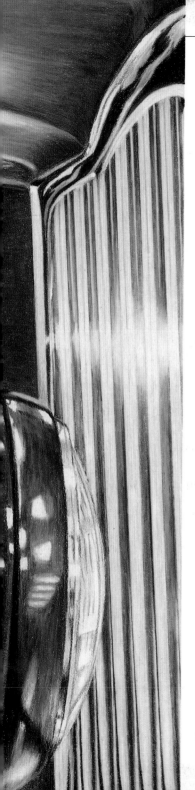

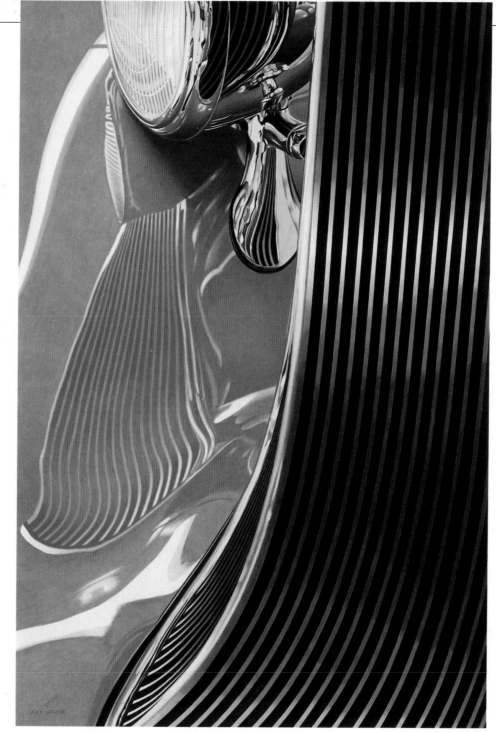

*1940 Packard, 18" x 27"*

*'32 Packard, 32" x 20"*

# Index